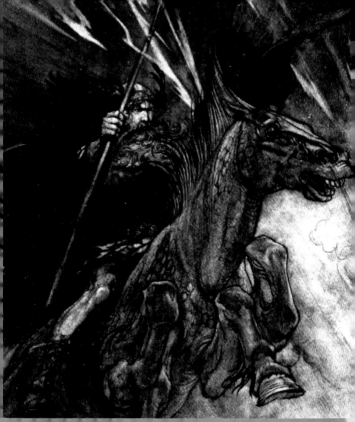

Mythical Creatures

By Lauren Bucca

A TINY FOLIO™
Abbeville Press Publishers
New York London

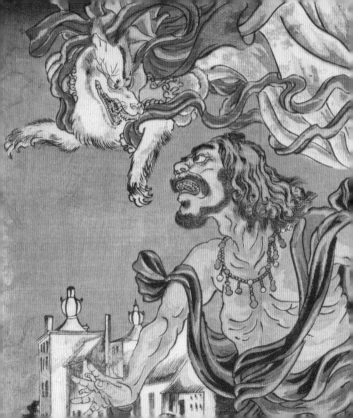

Introduction

Some mythical creatures have the power to make the earth turn and the skies thunder, while others have been known to pilfer your favorite pair of shoes. Some are larger than mountains and others no taller than a thimble. Some are benevolent and others wicked and still others ambivalent about their human neighbors. For as long as people have been telling stories, there have been mythical creatures.

A mythical creature is an animal or person who has supernatural physical features or abilities. They are "mythical" because they reside outside the realm of ordinary experience, but that does not necessarily make them fictitious. Indeed, many are believed to be real, even today. The divide between natural and supernatural became particularly evident in the West during the Enlightenment. Only what could be

scientifically observed was considered real, while the supernatural was considered a mere product of the imagination or the unconscious mind. However, earlier centuries held a different view, in which the familiar and fantastic coexisted.

This book highlights a range of creatures, including humans who shapeshift into other forms, such as vampires and werewolves; hybrids having the characteristics of both humans and animals, like the faun and mermaid; creatures that combine the features of various animals, such as the griffin and the Chinese luduan; and gods and goddesses with animal features or supernatural powers, such as Ammit, the Egyptian devourer of the dead, and Loki, the Norse trickster.

The category of shapeshifters may unsettle us the most, since they could secretly dwell among us. They spend their lives as humans except under special circumstances, or keep their nonhuman nature concealed, like Bram Stoker's famous vampire, Drac-

ula. The quintessential shapeshifter is the werewolf, who may first have emerged from an ancient Indo-European practice in which warriors mentally transformed themselves into wolves. Throughout history, people believed that werewolves existed like any another animal and would devour the unwary at night. This fear proliferated in medieval and early modern Europe, and in an extension of the witch hunts of that time, a number of people were put on trial for being werewolves. Many crimes, including murder, were attributed to the accused, and some were even sentenced to death. The immortality of the vampire and the nocturnal shapeshifting of the werewolf are examples of the magical powers possessed by many mythical creatures—although, as we will see, not all of them have such powers, despite their otherworldly appearance.

Mythical beings have long played a role in world mythology and religion, sometimes in explaining how our planet and the universe work. For instance,

the giant Typhon causes volcanoes to erupt, the World Turtle holds the earth on its shell, and the Moon Rabbit makes the rabbit-shaped shadow on the moon. They can also be invoked to explain daily occurrences, such as why a piece of furniture in your house might have moved (likely caused by a brownie, nisse, or yokai). In this way, they are an integral part of the human imagination, intrinsic to our interpretation of our world.

Mythical creatures are also found in fairy tales and folklore. Sometimes they are villains, employed to frighten children from running off to dangerous parts of the forest, and sometimes they help explain local occurrences, like ominous howls coming from the woods at night. But most often they serve a less utilitarian purpose. Our ancestors are sometimes accused of being too credulous or superstitious, but they—much like us—loved stories about fantastic creatures because those were the most entertaining ones.

Stories of mythical creatures gave rise to numerous artworks depicting them. The earliest examples appear in cave art, Mesopotamian cylinder seals, and the massive lamassu and sphinx statues that guarded cities and temples in Egypt and the Fertile Crescent. In the Middle Ages, they were depicted in illuminated manuscripts, particularly in bestiaries, which were illustrated collections of animals both real and imaginary. Each beast would be pictured in a small illustration, and its attributes and Christian symbolism would be described. Even real species were credited with magical qualities in bestiaries. Sometimes this may have been due to the bestiary writer's unfamiliarity with the animal, but there is also another explanation. During the Middle Ages, animals were commonly invested with symbolic meanings, which could lead to their attributes being embellished—for example, the pelican, identified with the Passion and the Eucharist, was believed to rend its own breast to feed its young with its blood. In the early modern

era, bestiaries were replaced with natural histories, which were more scientifically inclined, though they did sometimes contain one or two fantastic beasts.

The illustrations in this book are drawn not only from bestiaries but from a variety of different art forms, including Japanese prints, with their tumbling and troublemaking yokai; Victorian book illustrations and paintings, full of elaborately detailed fairies and dragons; Greek vases painted with creatures from myth; and even medieval ewers in the shape of fanciful beasts. Some creatures, however, are rarely depicted in art, living instead in oral narratives and dreams.

Though belief in the existence of magical creatures may have waned in the last hundred years, they continue to flourish in the popular imagination, appearing in fantasy and sci-fi novels, film and television, and role-playing games. Some people even claim to have witnessed them, as sightings persist of the Jersey Devil, the Goatman, the Loch Ness monster, and aliens.

In this little compendium—which is global, but by no means exhaustive—mythical creatures are classified according to where they spend most of their time: sky, land, forest, water, and divine realms. This is merely a starting point for exploring the multitude of creatures known to us, and those waiting to be discovered.

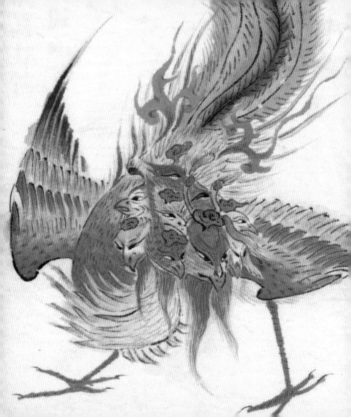

Chapter 1
SKY

In Western folklore, the dragon, with its powerful wings and fiery breath, reigns over the skies. It hoards stolen gold and hunts humans, and is a nearly invincible foe—although it may be vulnerable to a spear-thrust between its armored scales. Elsewhere in the world, however, the dragon has quite a different reputation. Asian dragons are benevolent: they give advice, prefer to walk rather than fly, and rarely breathe fire. Chinese dragons have the features of multiple creatures, including the head of a camel, the antlers of a deer, and the tusks of a boar, and they are also shapeshifters. The dragon remains an important symbol in China, taking part in New Year's parades. Japanese dragons are serpentine, rarely fly, have a long snout, and dispense

wisdom. Korean dragons are recognizable by their long beards.

Stories concerning winged creatures may have emerged from the limitations of human eyesight, especially before the advent of telescopes or binoculars. Without optical assistance, it is challenging to discern the true size of a bird's wingspan as it soars through the air. Written records reflect the difficulty of accurately observing the sky's inhabitants. In one account, Ibn Battuta, a fourteenth-century explorer from Morocco, reported that what first appeared to be a mountain turned out to be the mythical roc, a massive bird with the strength to carry elephants through the sky. Though some flying creatures may have their origins in misinterpreted sightings, others—like the Thunderbird of Native American mythology—were conceived to explain how the world works. The Thunderbird flaps its wings, and the skies pound out thunder; it blinks its eyelids, and lightning strikes.

Flying creatures appear frequently in art, sometimes even as heraldic symbols, such as the two-headed bird Gandabherunda, who is part of the official emblem of the Indian state of Karnataka, and the red dragon on the flag of Wales. While the depictions of some flying creatures have remained relatively constant, others have changed dramatically over time. The siren, from ancient Greece, was originally represented with a woman's head and torso and the body of a bird. But in later depictions, she takes the form of a mermaid, perhaps to embody the fantasies of sailors. And according to early legends, fairies were wingless and flew on the backs of birds. Their association with flight later gave them wings, especially during the Victorian era, when people claimed to capture them in photographs.

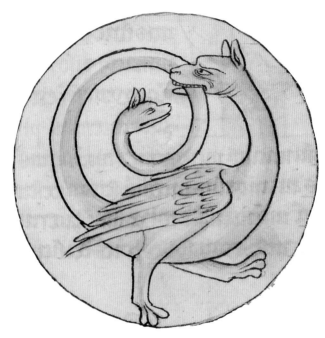

AMPHISBAENA · *Greek*
A two-headed beast who travels in either direction.
(Manuscript miniature, detail, c. 1250–60.)

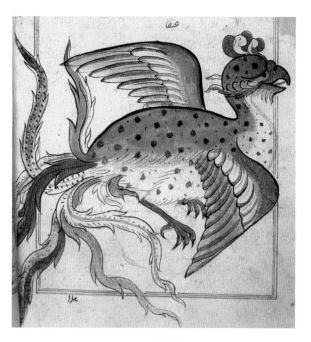

ANQA · *Arabian*
This massive bird is associated with the sun.
(Manuscript miniature, detail, eighteenth century.)

19

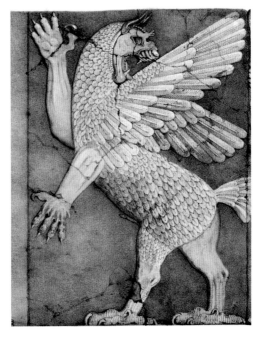

ANZU · *Mesopotamian*
A fire-breathing monster who stole the Tablet of Destinies.
(Drawing, detail, by L. Gruner, 1853.)

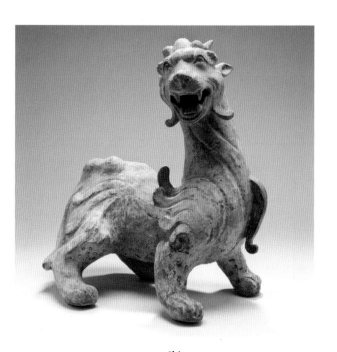

BIXIE · *Chinese*
Evil spirits flee from this winged lion; she guards tombs with her male counterpart, Tianlu. (Sculpture, 25–220 CE.)

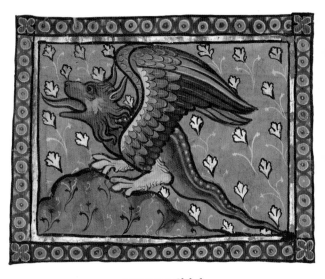

DRAGON · *Global*
Resembling a serpent or a lizard, a dragon often breathes fire and
hoards gold. (European manuscript miniature, detail, c. 1270.)

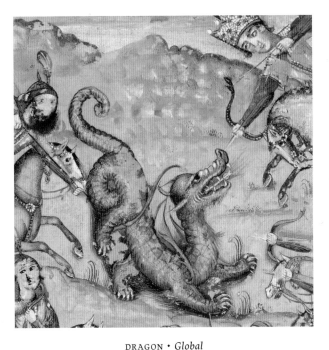

DRAGON · *Global*
King Bahram Gur fights a malicious dragon.
(Persian manuscript miniature, detail, c. seventeenth century.) 23

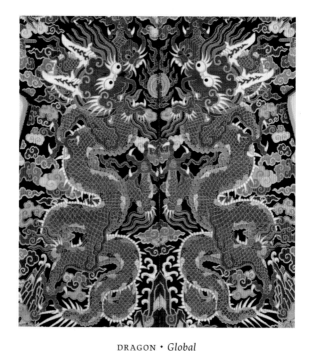

DRAGON · *Global*
This impressive creature is a popular motif in Qing dynasty
robe design, as seen above. (Robe, detail, seventeenth century.)

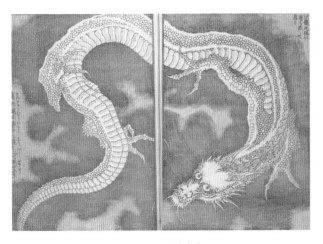

DRAGON • *Global*
Not all dragons fly, and some breathe wisdom instead of fire.
(Illustration by Katsushika Hokusai, c. 1836.)

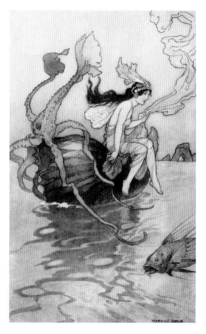

FAIRY • *European*
A diminutive being with a penchant for tricking humans.
(Illustration by Warwick Goble, 1920.)

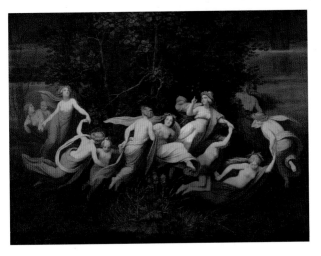

FAIRY · *European*
Wingless fairies still manage to glide through the air.
(Painting by Moritz von Schwind, 1844.)

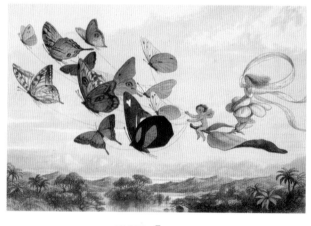

FAIRY · *European*
A clever fairy employs other winged creatures
for transportation. (Illustration by Richard Doyle, 1870.)

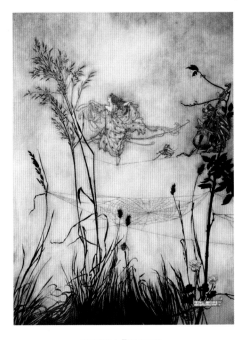

FAIRY • *European*
This fairy is a talented dancer, delicately balancing
on spider silk. (Illustration by Arthur Rackham, 1906.)

A Favorable Sign

This bird's name symbolizes harmony, showing how male and female, *feng* and *huang*, respectively, are one. As such, it appears as a good omen for momentous occasions—the crowning of a queen or king, or the beginning of a new era. When the bird disappears, difficult times may be ahead. This kaleidoscopic, multiheaded creature has a parrot-like beak, a duck's body, a peacock's tail, a swallow's wings, and crane-like legs.

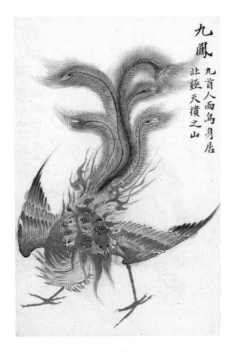

FENGHUANG • *Chinese*
(Illustration, c. 1644–1911.)

31

FIREBIRD • *Slavic*
A glowing bird that is highly sought, but is
a blessing and a curse for its captor.
(Painting, detail, by Viktor Vasnetsov, 1880.)

GAMAYUN · *Russian*
A prophetic bird with a woman's face.
(Painting, detail, by Viktor Vasnetsov, 1895.)

Elephantine Strength

The name Gandabherunda means "having terrible cheeks," and this two-headed bird is indeed impressive, being one of the most extraordinary creatures of its kind in Hindu mythology. It demonstrates its strength by carrying large animals, such as elephants, as depicted in the facing textile. As a symbol of power, Gandabherunda appears in the official state emblem of Karnataka and in temple architecture.

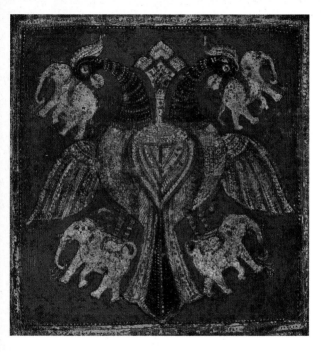

GANDABHERUNDA · *Hindu*
(Watercolor on cloth, c. 1650–1700.)

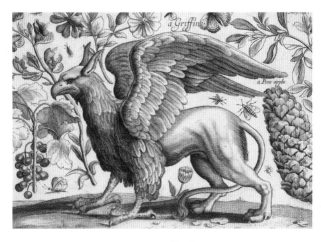

GRIFFIN · *Persian*
This creature, possessing a bird's head and wings
and a lion's body, is a fierce protector.
(Etching, detail, after Wenceslaus Hollar, 1662–63.)

36

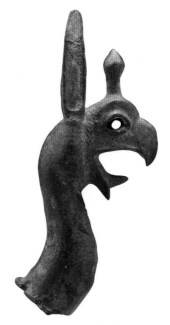

GRIFFIN • *Persian*
The griffin was even popular in antiquity; this one decorated
a Greek cauldron. (Bronze protome, c. 600 BCE.)

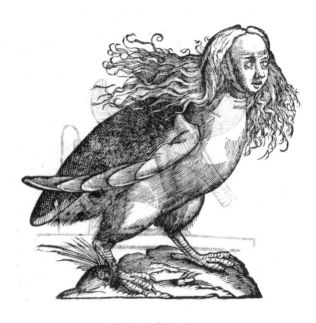

HARPY · *Greco-Roman*
A human-bird hybrid, wind spirit, and tormentor
of wrongdoers. (Illustration by Giovanni Battista
Coriolano, detail, 1642.)

HIPPOGRIFF · *Italian*
Resembling a griffin and a horse, this noble
creature flies swiftly.
(Statue by Auguste Nicolas Cain, 1879.)

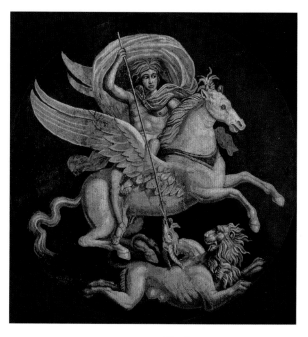

PEGASUS · *Greek*
Pegasus, a flying horse, emerged from Medusa's blood after
she was beheaded by Perseus. (Mosaic, 100–299 CE.)

40

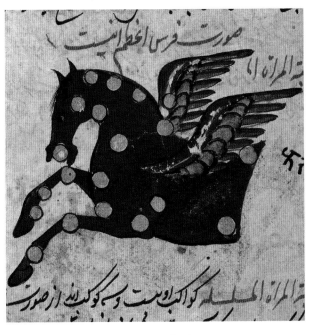

PEGASUS • *Greek*
This horse inspired the name of a constellation.
(Manuscript illustration, detail.)

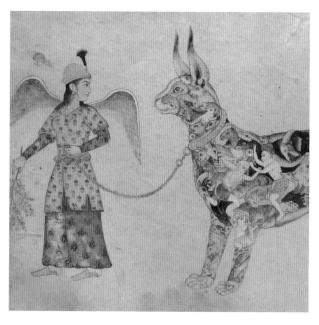

PERI · *Persian*
A winged, troublemaking spirit, who sometimes likes to help
people. (*Left*; painting, detail, c. nineteenth century.)

PERI · *Persian*
The Youth of Rum imagines meeting a peri,
and her colorfully winged companions, each night.
(Illustration by Manohar, detail, 1597–98.)

43

Bird Reborn

When the phoenix's death draws near, it creates a nest of scented boughs. After settling into its nest, the bird bursts into flames and is consumed by the fire. But this isn't the end for the phoenix. A new creature arises from the embers and begins a fresh life. The phoenix is present in many cultures, and its symbolism of immortality was widely adopted in Rome—the eternal city—and in Christianity, as representing the Resurrection.

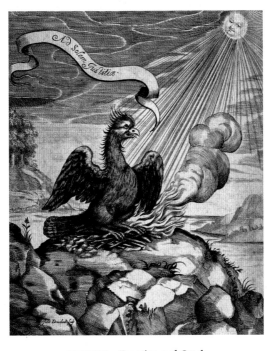

PHOENIX · *Egyptian and Greek*
(Engraving by John Droeshout, c. early seventeenth century.) 45

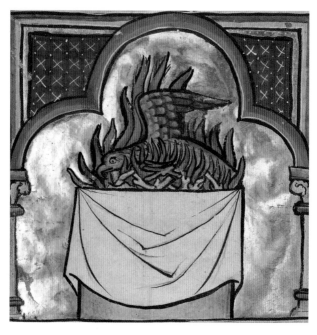

PHOENIX · *Egyptian and Greek*
In this bestiary illustration, a phoenix has not yet risen from
its fiery pyre. (Manuscript miniature, detail, c. 1270.)

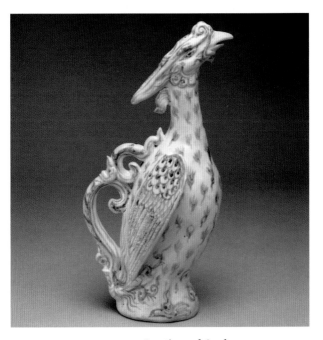

PHOENIX · *Egyptian and Greek*
A phoenix is somewhat ironically used to decorate an ewer,
a water-pouring vessel. (Ewer, c. 1400–1599.)

Lord of the Skies

While the wingspan of an eagle—which is sometimes up to eight feet—may seem impressive, Roc puts all other birds of prey in their place. His wingspan is reputedly eighty feet, and his body is a grand thirty feet. Some report that he even blocks the sun with his body and massive wings, and that he catches elephants. Roc lives in a valley filled with gemstones; he is furious with sneaky Sinbad for stealing his jewels and escaping the valley, but that's a story for another time.

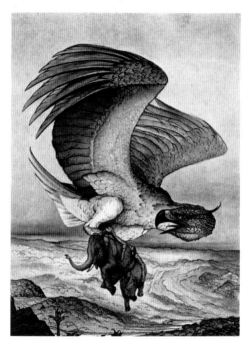

ROC · *Arabian*
(Illustration by Edward Julius Detmold, 1924.)

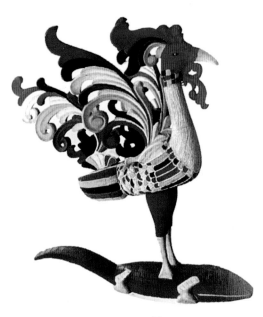

SARIMANOK • *Maranao*
A bird with colorful plumage, and a symbol
of good fortune. (Statue.)

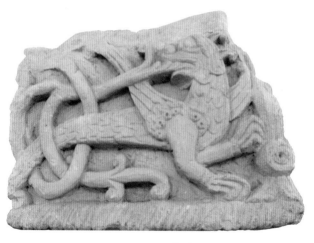

SIMARGL · *Slavic*
A winged creature with a dog's head, comparable to the
simurgh. (Stone capital, twelfth century.)

Foster Bird

In the *Book of Kings*, we learn of Zal, a royal child born with snow-white hair. His hair is viewed as a sign of demonic possession, so his father abandons him at the foot of Mount Alburz. Thankfully, a majestic bird known as the simurgh finds the child and raises him as her own. Zal is eventually reunited with his father, but before he leaves the nest, the simurgh gives the prince two of her feathers, which if burned will summon her to the prince's aid.

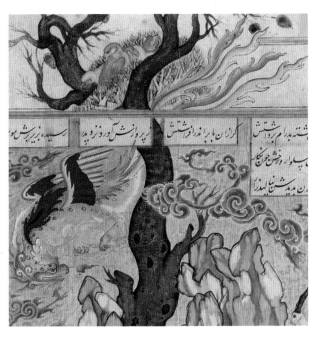

SIMURGH • *Persian*
(*Bottom left*; manuscript miniature, detail, attributed to
Sadiqi Beg, 1576–77.) 53

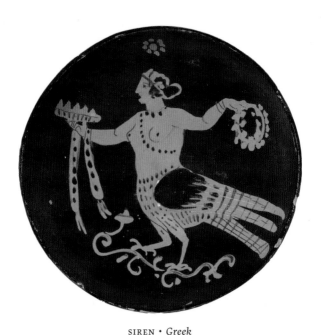

SIREN • *Greek*
A winged, womanlike creature, who lures sailors to their
deaths with her beautiful music. (Kylix attributed to the
Asteas Workshop, detail, late fourth century BCE.)

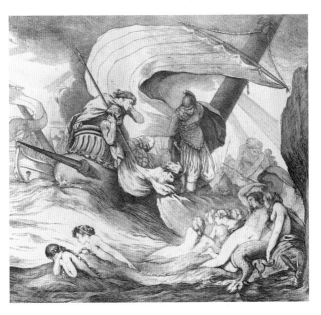

SIREN · *Greek*
In later depictions, sirens are beautiful, wingless
women—here they pull Odysseus's ship into the sea.
(Etching, detail, by François Hutin, 1742.)

55

A Bittersweet Song

Like the Greek siren, the Russian sirin has a bird's body and a woman's head, though she sets herself apart by wearing a crown. She is visually striking, and only sings her melodic song to the upright. Her music is meant to bless others, rather than lure the unsuspecting to an untimely demise—though it eventually leads her listeners to forgetfulness, and then death.

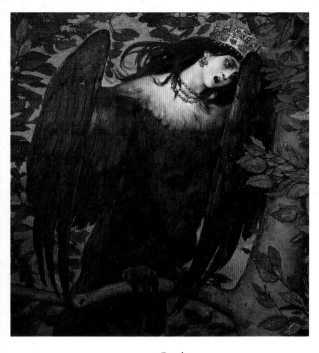

SIRIN • *Russian*
(Painting by Viktor Vasnetsov, detail, 1896.)

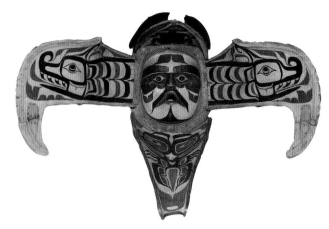

THUNDERBIRD · *North American*
A powerful bird whose wings make the sound of thunder
when it flies. (Mask by Namgis, nineteenth century.)

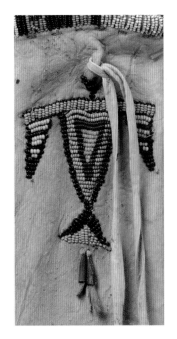

THUNDERBIRD · *North American*
Lightning flashes from this bird's beak.
(Tobacco bag, detail, c. 1870.)

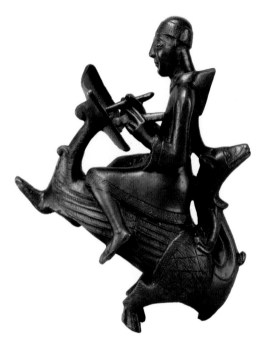

WYVERN • *European*
The wyvern, unlike a dragon, does not typically
breathe fire and only has two legs. (Statue, c. 1150.)

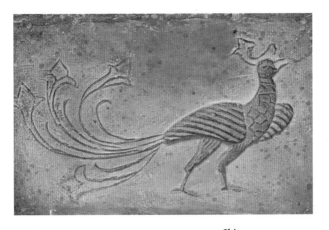

ZHU QUE OR VERMILION BIRD • *Chinese*
This flame-covered creature is one of the Four Symbols of the
Chinese constellations. (Stove model panel, 202 BCE–9 CE.)

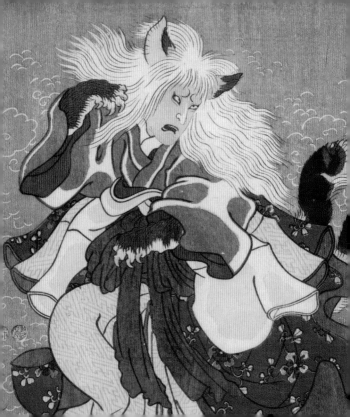

Chapter 2
LAND

Most mythical creatures do not soar through the skies, but roam the earth. Ever restless, they climb the highest mountains, skulk in caverns, appear to travelers walking the road on a snowy night, and even sneak into our homes. They are an intimate part of the human world, and as such, they repeatedly return to our stories and art. The mythical creatures of the land are a dynamic group, but can roughly be categorized as animal-human hybrids, fantastic beasts, and mischief-making spirits.

We humans have had a long, complex relationship with our animal nature, which manifests itself in countless animal-human hybrids worldwide. The most terrifying animal-human hybrids may be those with human heads and animal bodies, like

the lamassu, lamia, manussiha, and sphinx. They have that most uniquely human feature, a face, but the rest of them reveals their otherworldliness. More approachable, in certain ways, are those creatures with human bodies and animal heads, such as the cynocephalus, which has the head of a dog or jackal. One notable example is that of Saint Christopher. According to some traditions, the Christian saint had the head of a dog, but became more humanlike—and gave up barking—after his conversion. The lesson that a people can be rescued from their animal nature has parallels across cultures.

Animal-human hybrids encapsulate our fears and desires: their human aspects are familiar to us, but their animal aspects give them capabilities far beyond our own. Today's equivalents might be superheroes—though Batman would be more frightening if he had webbed wings, or Spiderman, if he had a spider's fangs.

Horses have long played a role in humanity's history. They have been domesticated since ancient times, and the bond between horse and rider may have inspired tales of mythical steeds, like Pegasus from chapter 1. Of the

mythical horses, the unicorn is perhaps the most recognizable. This gleaming white horse with a single horn has captivated the human imagination for thousands of years, appearing everywhere from ancient cylinder seals to the royal arms of Scotland. Like certain other mythical creatures, the unicorn may have been inspired by confused sightings or accounts of real animals, such as the oryx, a kind of antelope with two nearly straight horns. The first written description of the unicorn appears in the fourth century BCE, in a natural history book by the Greek physician Ctesias, who claimed that the species was to be found in India. The unicorn's horn was believed to have magical and healing properties, and as late as the eighteenth century, narwhal tusks were sold as unicorn horns.

In medieval Europe, the unicorn was less important for its magical horn than as a symbol of purity. This wild, even invincible creature could be tamed only by a virgin, and would rest its head in her lap. The unicorn was frequently represented in art, such as the late Gothic tapestry cycle depicting a unicorn hunt that now hangs in the Cloisters in New York. By the time of the Enlightenment,

the unicorn had largely been relegated to the realm of fantasy, though embers of belief in its existence linger today.

The unicorn remains an image of goodness and innocence, but this is not often the case with mythical beasts. One of them, the brutal Nemean Lion, was so fearsome that Heracles was ordered to slay it as the first of his twelve labors. This beast could survive any arrow, so the hero killed it with his bare hands and a wooden club, and then made a cape of its skin. Closer to our own time, another terrifying creature, the Beast of Gévaudan, was blamed for killing dozens of peasants in eighteenth-century France. Though the victims were likely killed by multiple different wolves or wolf packs, the notion that one creature was responsible for the attacks captivated the public imagination.

Of the land-dwelling mythical creatures, the yokai of Japan are the most diverse. These spirits may be the reason why a light in your house inexplicably

turns on, or they might be the source of a voice you hear when you cross a certain bridge. They are mischievous and entertaining, and though yokai is sometimes translated as "demon," they are neither good nor evil. Because yokai are shapeshifters, they may appear in many forms, such as oni, who looks like an ogre, and kitsune, who is a fox. Japanese artists have depicted yokai in several media, but one of the most interesting is netsuke, which were used to attach a small container to a kimono sash. Though these ivory carvings are typically only a couple inches tall, they are quite intricate, and express an impressive depth of emotion for their diminutive size.

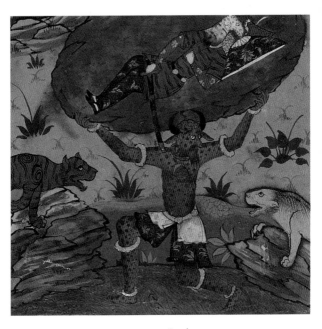

AKVAN · *Persian*

A demon with red skin, Akvan effortlessly lifts the warrior
Rustam into the sky. (Manuscript miniature,
detail, sixteenth century.)

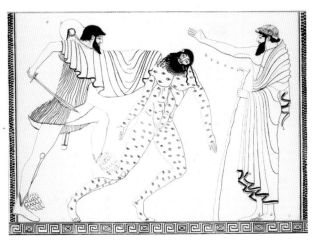

ARGUS PANOPTES · *Greek*
This being's eyes, which once covered his body,
were transferred to a peacock's tail.
(*Center*; engraving by Alexis Louis Pierre, 1844–61.)

More Tea?

This yokai is based on a real animal, a raccoon dog or tanuki. The shapeshifting bake-danuki usually likes to make trouble, or make noise by drumming its belly. It especially enjoys watching people get lost. Sometimes, though, it uses its transforming talents for good. In one story, a bake-danuki turns into a self-replenishing teapot—much to the delight of a monk named Shukaku.

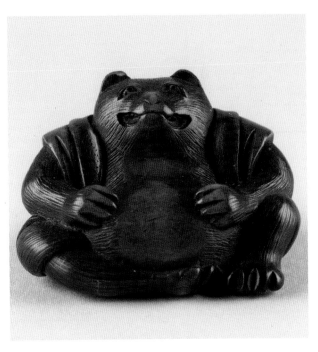

BAKE-DANUKI • *Japanese*
(Netsuke, nineteenth century.)

71

BAKU · *Japanese*

The baku has an elephant's trunk, a rhino's eyes, an ox's tail, and a tiger's paws. (Netsuke by Sadatake, eighteenth century.)

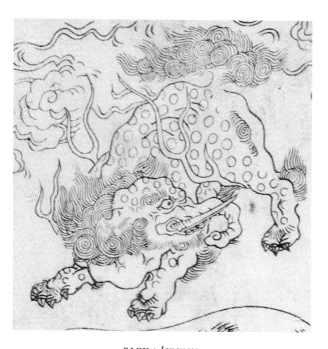

BAKU • *Japanese*
This benevolent yokai devours nightmares.
(Print, detail, by Tachibana Morikuni, detail, c. 1740.)

A Haunting Cry

A person drawing near to death may hear the wail of a banshee. The banshee's cry is meant to be a sign for the one dying, or for their family, that the end is close. Unlike the banshee in the facing illustration, most are heard rather than seen. This elusive being, whose name in Celtic means "woman of the fairies," lives beneath mounds in the Irish countryside.

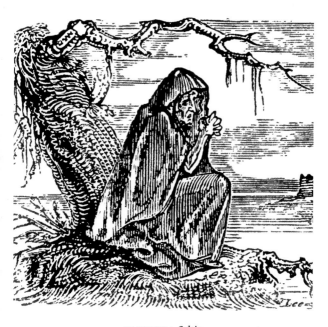

BANSHEE • *Celtic*
(Illustration, detail, by William Henry Brooke, 1834.) 75

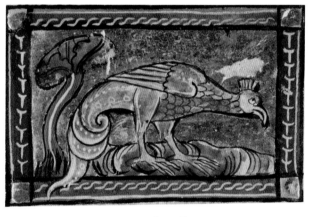

BASILISK · *Greco-Roman*
This reptilian creature can kill with its gaze alone, but it is
weakened by the scent of a weasel.
(Manuscript miniature, detail, c. 1340–50.)

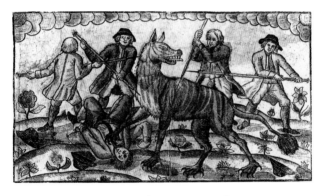

BEAST OF GÉVAUDAN • *French*
This man-eating, wolfish creature terrorized the former
French province of Gévaudan.
(Drawing by Thomas Borup, late eighteenth century.)

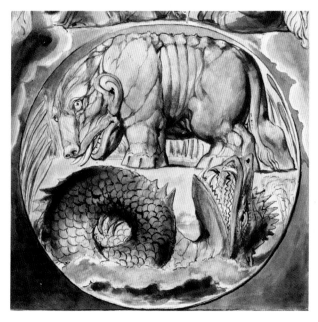

BEHEMOTH · *Biblical*
A biblical monster with extraordinary strength,
often identified as a hippo.
(*Top*; painting by William Blake, detail, 1821.)

BROWNIE • *Scottish*
A type of fairy who cleans the house while
everyone sleeps (and likes to fish, too).
(Illustration by Palmer Cox, detail, 1890.)

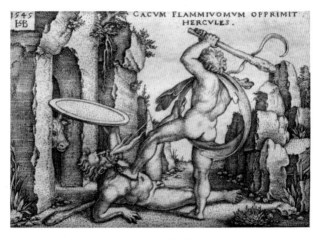

CACVM FLAMMIVOMVM OPPRIMIT
HERCVLES.

1545
HSB

CACUS · *Greek*
A fire-breathing giant, and cattle thief,
who is killed by Heracles.
(Engraving by Hans Sebald Beham, sixteenth century.)

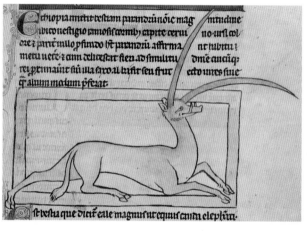

CENTICORE · *European*
A creature with a boar's tusks, goatlike hooves,
and horns that rotate if desired.
(Manuscript miniature, detail, c. 1250–60.)

81

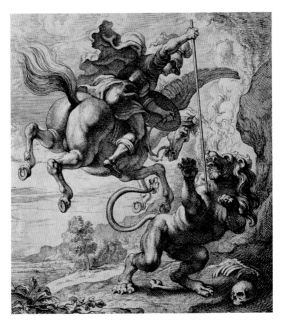

CHIMERA · *Greek*
A fire-breathing creature resembling a lion, goat, and dragon.
(*Bottom right*; etching by Theodor van Thulden, after
Peter Paul Rubens, c. 1640.)

COCKATRICE • *Greco-Roman*
This serpent-like creature causes death by its glance or
breath, but dies if it hears a rooster crow.
(Manuscript miniature, detail, fifteenth century.)

Singular Craftsmen

These one-eyed giants may be known to eat shepherds, but they also have a softer, more creative side. The cyclopes, a race of giants possessing a single eye, helped Hephaestus craft Zeus's thunderbolt, Hades's helmet, and Poseidon's trident. They're depicted hard at work in the facing engraving.

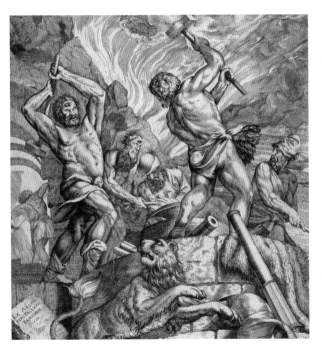

CYCLOPES · *Greek*
(Engraving by Cornelis Cort, after Titian, 1572.)

CYNOCEPHALUS · *Global*
A creature with the body of a human and the head
of a dog, here depicting Saint Christopher.
(Icon, seventeenth century.)

DAITYA · *Hindu*
A powerful giant with a beastly head, who defies the gods.
(*Bottom right*; lithograph,
detail, by Kusha Buvra Ramji, 1890.)

87

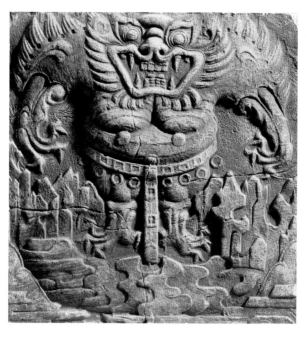

DOKKAEBI • *Korean*
This goblin-like creature loves to wrestle. (Earthenware tile.)

FACHAN • *Scottish*
An excellent woodcutter, despite having only one arm,
eye, and leg. (Illustration, detail, 1862.)

89

GHOUL • *Arabian*
A demonic spirit who lives in burial grounds and
eats human flesh. (Print, detail, by Art Young, 1912.)

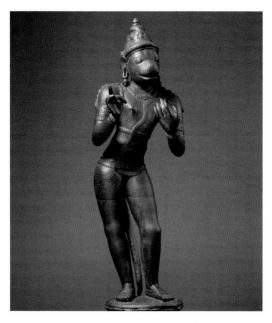

HANUMAN · *Hindu*
This monkey-human deity exhibits great courage in the *Ramayana* epic, and is also known for his integrity and sensitivity. (Statue, eleventh century.)

The Lincoln Imp

Sometimes a companion to the devil, this creature behaves accordingly. The legend of the Lincoln Imp relates that the mischievous creature, who was ransacking Lincoln Cathedral with its friends, was turned into stone by an angel. The imp can be seen in the cathedral architecture today, appearing much like the other stone grotesques.

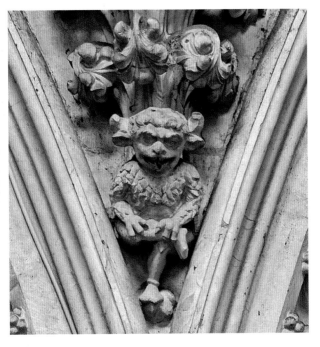

IMP · *European*
(Grotesque, detail, c. fourteenth century.)

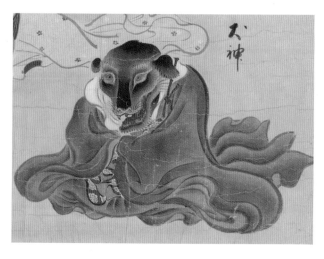

犬神

INUGAMI · *Japanese*
A spirit-possessed dog.
(Scroll painting, detail, c. 1600.)

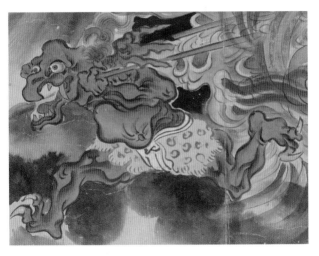

KASHA · *Japanese*
A yokai who steals the corpses of evil people
and transports them to hell in its fiery chariot.
(Scroll painting, detail, c. 1600.)

The Wily Fox

This shapeshifting yokai appears in numerous stories and frequently takes the form of a beautiful woman. It has a penchant for deceiving men in particular, from peasants to kings. In the facing print, a king has just made a surprising discovery: his wife is not a woman, but a kitsune.

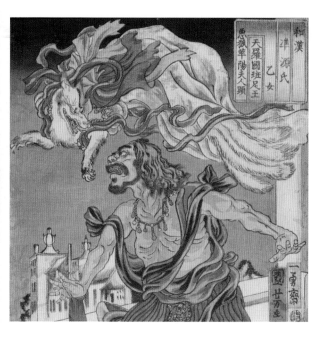

KITSUNE • *Japanese*
(Woodblock print, detail, by Utagawa Kuniyoshi, 1855.) 97

Winged Protector

The lamassu, with the head of a man, the body of a lion or bull, and the wings of an eagle, strikes fear into those who see it. For this reason, a lamassu (with his brothers) guards the gates of Assyrian and Babylonian cities and palaces, standing tall and imposing. If the statue is viewed from the front, it seems like a stoic guard, but when observed from the side, it appears to be moving.

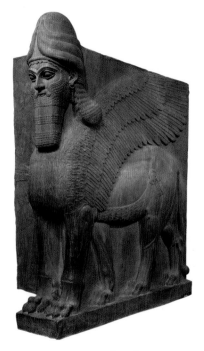

LAMASSU • *Assyrian*
(Statue, c. 883–59 BCE.)

LAMIA • *Greek*
A seductress and devourer of children, this demon resembles
a scaly woman-goat. (Illustration, detail, c. 1600.)

LEPRECHAUN • *Irish*
A fairy shoemaker with a hidden pot of gold.
(Illustration by John D. Batten, 1892.)

LEUCROTTA · *Indian*
A dangerous dog-wolf hybrid and hunter of humans.
(Manuscript miniature, detail, fifteenth century.)

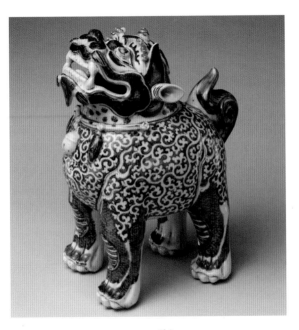

LUDUAN · *Chinese*
When an upright ruler ascends the throne, this creature
masters all foreign languages. (Porcelain censer,
early seventeenth century.)

The Compassionate Snake

Madame, or Lady, White Snake appears in the popular Chinese *Legend of the White Snake*. In the story, Madame White Snake transforms into a woman to save a green snake on land. The two snakes soon become like sisters. Later, they both assume the form of women and find loving relationships. At the point in the story depicted here, the true nature of Madame White Snake is fully revealed.

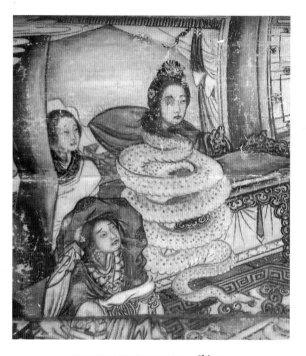

MADAME WHITE SNAKE • *Chinese*
(*Right*; painting, detail, c. late nineteenth century.)

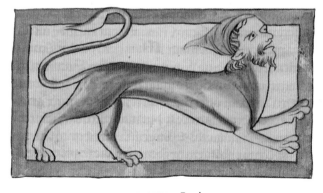

MANTICORE · *Persian*
This creature's name comes from the Persian word for
"man-eater"; it has a human's head and a lion's body.
(Manuscript miniature, detail, c. 1250–60.)

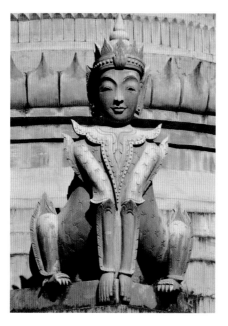

MANUSSIHA · *Burmese*
A half man and half lion, he once
saved a baby from ogresses.
(Statue, c. 1600–1799.)

Deadly Eyes

The Gorgon sisters are winged beings with living snakes for hair, and those unlucky enough to look into their eyes turn into stone. Of the three Gorgons, Medusa was the only mortal one. She was beheaded by Perseus, who used a mirrored shield to gaze upon the Gorgon without experiencing an unpleasant transformation. Perseus, though, was in for a surprise, as Pegasus (a winged horse) and Chrysaor (a giant) emerged from Medusa's body after she was killed.

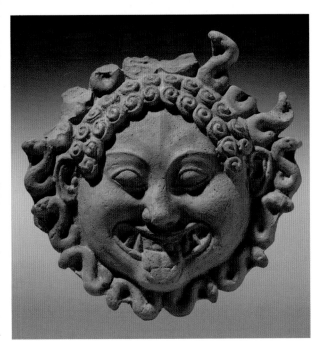

MEDUSA · *Greek*
(Roof tile, c. 500 BCE.)

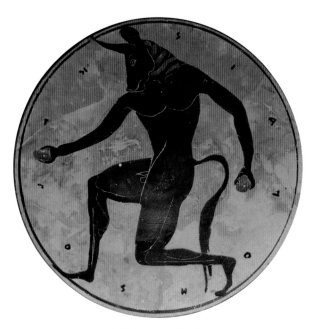

MINOTAUR · *Greek*
A creature with a man's body and a bull's head and tail.
(Kylix, detail, by the Painter of London, c. 515 BCE.)

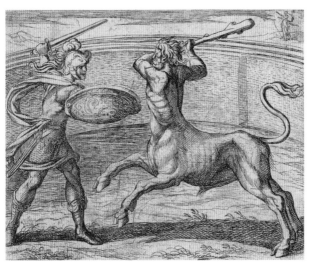

MINOTAUR • *Greek*
Theseus kills the Minotaur in its Labyrinth; here
the Minotaur is depicted like a centaur.
(Etching, detail, by Antonio Tempesta, 1606.)

111

Guardian at the Gate

This creature has the talons of an eagle, the limbs of a lion, the head and neck of a viper, and the tail of a scorpion. Considering its mixed-up form, it's clear why the mushussu is known as a dragon of chaos. Due to its power and fearsome appearance, this creature once protected Babylon, as seen in the facing replica of the city's gates.

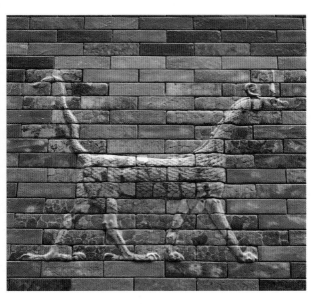

MUSHUSSU · *Mesopotamian*
(Ishtar Gate replica, detail, 1918.)

113

A Hungry Cat

This is no ordinary cat. According to some folklore, it is believed that a cat may develop a forked tail when it grows old, and subsequently behaves maliciously. This folklore might have inspired the legend of the nekomata. Living in the forest, the nekomata can grow to quite an intimidating size, like the one in this print. This yokai also has an alarming appetite for human flesh— it can eat ten people in an evening.

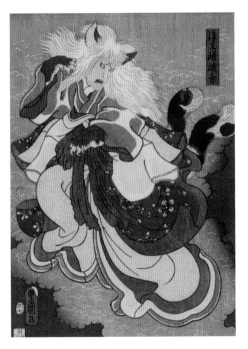

NEKOMATA • *Japanese*
(Woodblock print by Utagawa Kunisada, 1853.)

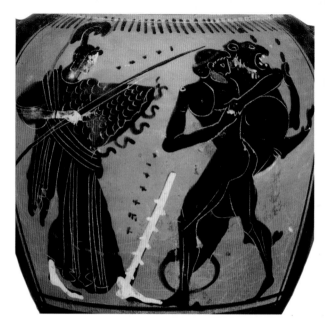

NEMEAN LION • *Greek*
A lion with golden fur, it's impervious to arrows
but is ultimately killed by Heracles. (Amphora, detail,
attributed to the Diosphos Painter, c. 500 BCE.)

NISSE • *Scandinavian*
A kind of goblin, often wearing a red cap, who sneaks into houses and barns. (Card illustration by Julius Holck, 1895.)

A Complex Cannibal

This cannibalistic yokai has a hideous appearance, much like an ogre, and is large and strong. It is recognizable by its horns and red, blue, yellow, or green color, and although most oni are male, females are also known to exist. In perhaps not the kindest gesture, artists have typically represented female oni as angry and bitter. Oni may not be the friendliest, but they can't be pigeonholed—some have even converted to Buddhism.

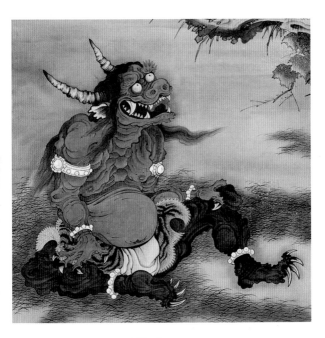

ONI • *Japanese*
(Hanging scroll painting, detail, by Soga Shohaku, c. 1764.) 119

ONOCENTAUR · *Greek*
A human-donkey hybrid with only two legs,
who symbolizes male lust. (Illustration, detail, 1890.)

120

OPHIOTAURUS · *Greek*
This creature is a bull-serpent hybrid, with supposedly
magical entrails. (Mosaic, 44–410 CE.)

ORTHOS · *Greek*
This two-headed dog is brother to Cerberus and father
of the Sphinx. (Kylix, detail, by Kachrylion, potter,
and Euphronios, painter, 510–500 BCE.)

PARANDRUS · *Greek*
A creature that looks like a reindeer and camouflages
itself like a chameleon. (Manuscript miniature,
detail, c. 1250–60.)

Good Omen

This creature has a horselike body, covered in scales that glow with flame. If you hear the pleasant voice of a qilin, good luck will follow. Though it's a powerful creature, a qilin is also kind, aiming to not harm any living thing—except when it breathes fire on good people's enemies. Curiously, the giraffe became associated with this creature when an emperor claimed that the animal and mythical beast were the same. Today, the Japanese and Korean languages have the same word for qilin and giraffe.

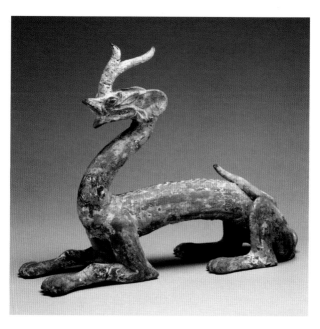

QILIN · *Chinese*
(Statue, 300–499 CE.)

Growling Belly

This creature has a serpent's head and neck, a leopard's body, a lion's haunches, and a deer's feet, though, in one Arthurian tale, it has dazzling green eyes and a white body. The Questing Beast is difficult to capture, but not to hear. Its belly makes such a din that people say it reminds them of baying or "questing" hounds in pursuit of their prey.

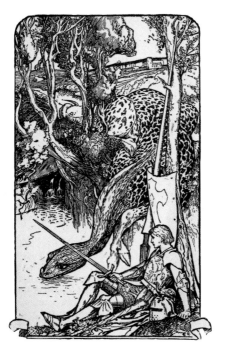

QUESTING BEAST • *French*
(Illustration by H. J. Ford, 1908.)

SANDMAN · *English*
The Sandman once threw sand into sleepless children's
eyes; now he sends good dreams.
(Illustration by Hans Tegner, 1900.)

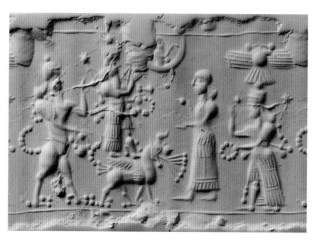

SCORPION MAN · *Mesopotamian*
A man with a scorpion's body who appears in the *Epic of Gilgamesh* as a guardian of the sun god's gates.
(*Far left;* cylinder seal, detail, eighth century BCE.)

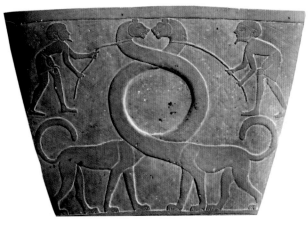

SERPOPARD · *Egyptian and Mesopotamian*
A beast with a leopard's body and a serpent's neck and head.
(Narmer Palette, detail, c. 3100 BCE.)

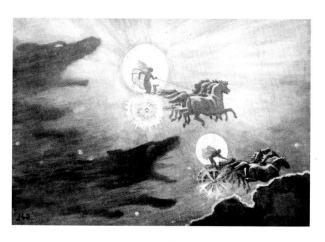

SKOLL • *Norse*
This colossal wolf chases the sun as it journeys across the
heavens. (*Left*; illustration by J. C. Dollman, 1909.)

The Riddle

Having a woman's chest and face, a lion's body, and a bird's wings, the Sphinx is a daunting monster to encounter. As guardian of Thebes, she only allows people to pass through the gates if they correctly answer her riddle: *what goes on four feet in the morning, two feet in midday, and three feet in the evening?* Oedipus is the first to answer correctly (a man). After this, the Sphinx throws herself off a cliff, and Oedipus becomes king.

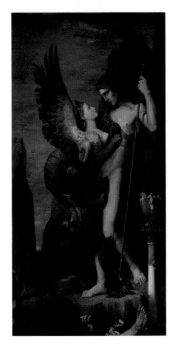

SPHINX · *Greek*
(Painting by Gustave Moreau, 1864.)

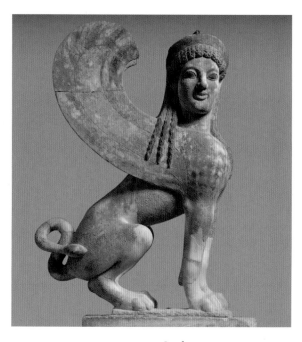

SPHINX · *Greek*
The Sphinx learned her riddle from the Muses.
(Capital, detail, c. 530 BCE.)

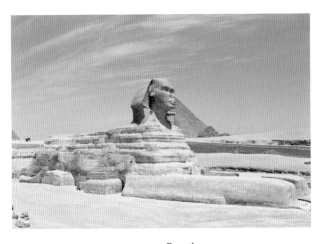

SPHINX · *Egyptian*
This Egyptian sphinx, whose face likely depicts King Khafre,
protects the pyramids. (Statue, c. 2575–2465 BCE.)

A Transformed Monkey

Sun Wukong is king of the monkeys. He carries mountains, transforms into other animals, and freezes his opponents with magic. As a condition of being released from imprisonment, this monkey dedicated himself to protecting a monk and learning from the Buddha's teachings.

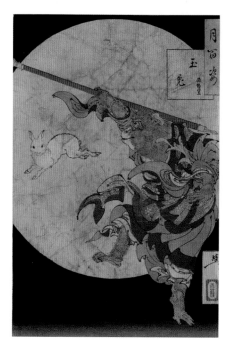

SUN WUKONG • *Chinese*
(Woodblock print by Tsukioka Yoshitoshi, c. 1880.)

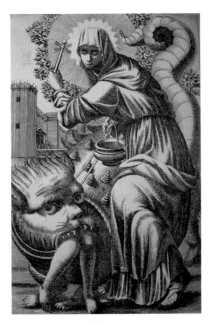

TARASQUE · *French*
A malevolent dragon-like creature with a lion's head; it is
defeated by Saint Martha. (Engraving by Jean Le Blond,
c. seventeenth century.)

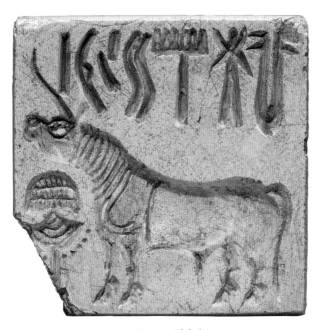

UNICORN • *Global*
This magical horse typically has a single horn issuing from
its head. (Seal, c. 2000 BCE.)

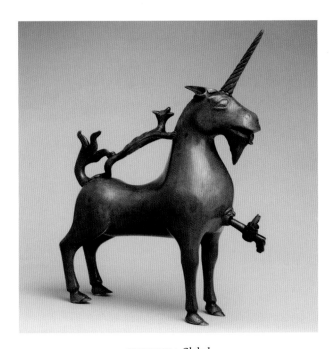

UNICORN · *Global*
The city of Nuremberg, where this hand-washing tool was
140 made, was obsessed with unicorns. (Aquamanile, c. 1425–50.)

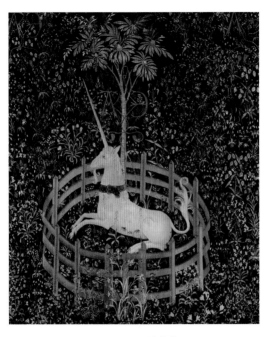

UNICORN · *Global*
This captive unicorn may represent the subduing
of one's beloved. (Tapestry, detail, 1495–1505.)

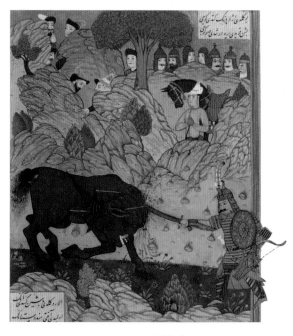

UNICORN · *Global*
Bahram Gur slays a unicorn in this Persian illustration from
the *Book of Kings*. (Manuscript miniature, detail, 1616–20.)

142

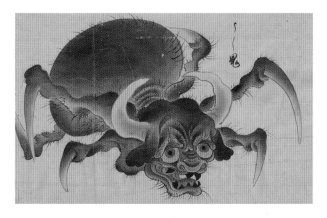

USHI-ONI · *Japanese*
A creature with an ox's head and a spider's body, it spits
poison and eats humans. (Scroll painting, detail, c. 1600.) 143

UWAN · *Japanese*

This yokai has blackened teeth, three fingers on each hand,
and mysterious origins. (Scroll painting, detail, c. 1600.)

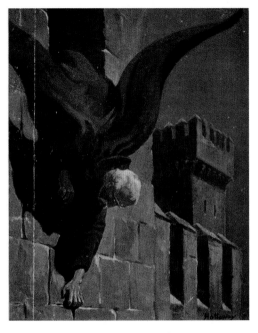

VAMPIRE · *Global*
Survives on the blood of the living and has a keen sense of
smell. (Book cover, detail, by Edgar Alfred Holloway, 1919.) 145

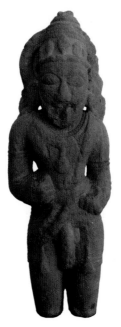

VETALA · *Hindu*
A kind of jinn (genie) who inhabits the body of a
deceased person. (Statue, twelfth century.)

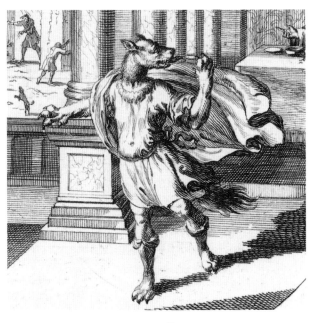

WEREWOLF • *European*
A human who transforms into a wolf, or wolflike creature,
during a full moon. (Etching, detail, by Georg Andreas
Wolfgang the Elder, 1665.)

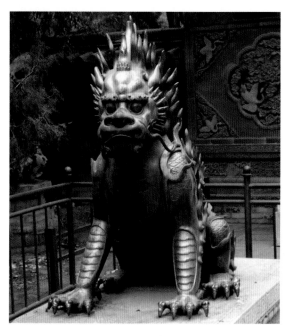

XIEZHI • *Chinese*
This beast, a symbol of justice, identifies the guilty
by pointing with its horn. (Statue.)

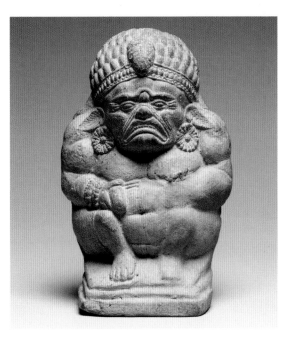

YAKSHA · *Hindu and Buddhist*
A nature spirit who might eat travelers.
(Rattle, first century BCE.)

Friend of Humans

This creature is said to have authority over the animal world, and with good reason. It is strong and powerful, with a lion's body and an elephant's trunk and tusks. It is one of the fiercest protectors of temples, and also looks after the physical and spiritual well-being of humans.

YALI · *Hindu*
(Bracket, seventeenth century.)

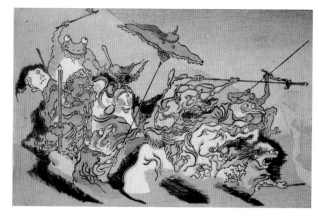

YOKAI • *Japanese*
Yokai are spirits, sometimes called demons, that resemble
animals and possess supernatural powers.
(Illustration, detail, by Kawanabe Kyosai, 1890.)

YUKI-ONNA • *Japanese*
A ghostly figure, she appears on snowy nights, and
may be dangerous to humans. (Woodblock print,
detail, by Katsukawa Shunsho, 1770.)

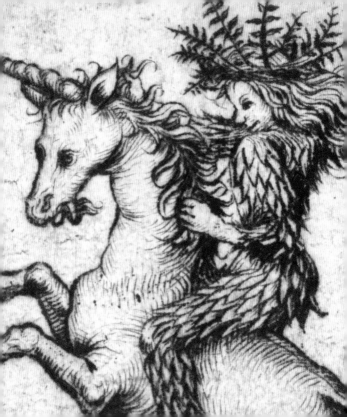

Chapter 3
FOREST

Among the mythical creatures of the land, those of the forest merit their own chapter. In parts of the world densely covered in trees, such as Bavaria, Russia, Scandinavia, and the American Northwoods, forest tales abound. They draw inspiration from the darkness of the forest, its nooks and crannies, and its tricks of light and sound—the eerie light at dusk, the creaking of tree limbs, the wind through the rustling leaves that sounds like a human voice.

The mythical creatures of the forest embody the uncanniness of their woodland homes, and as such, most are mischievous. Though they may terrify less than other magical beings, they should generally be avoided. Trolls, for instance, possess admirable qualities but are still best encountered when the sunlight

has turned them to stone. Forest creatures may be classified into humanlike beings; animals with extraordinary powers, like tsuchigumo, a crafty spider yokai; and monsters, like the lindworm, whose sinuous body winds its way under leaves and around trees.

In Western folklore, the humanlike creatures of the forest include the following, roughly descending in size: giants and ogres; trolls, who vary in height but are usually seven or eight feet tall; wood nymphs, also known as dryads; and goblins, gnomes, and dwarves. It may seem odd that so many woodland beings have a human appearance, despite the forest having more than enough animals to inspire all kinds of fantastic inventions. This may have something to do with the association between humans and trees, whose trunks and branches may be compared to our bodies and limbs.

The forest, also, may evoke humanity's wild, untamed nature. The Wild Man and Wild Woman, particularly the former, were frequently depicted

during the medieval and early modern periods. Perhaps imitating the desert ascetic John the Baptist, the Wild Man was covered in hair and could be found roaming the margins of illuminated manuscripts. He could even inspire wild behavior in real people. In the late fourteenth century, Charles VI of France and several others attended a ball dressed in shaggy costumes, to emulate this mythical being. Their hairy clothes accidentally caught on fire, but the king was saved when a duchess threw her skirts over him to extinguish the flames.

Many of the illustrations of forest creatures in the following pages are taken from storybooks, as reading or hearing stories about the woods has been, and remains, a comforting way to pass a cold winter's night.

A Fierce Foe

A centaur is strikingly human, having a man's head, arms, and chest, but possessing the legs and lower half of a horse. He may have originated from a forest spirit mating with a wild mountain man, a theory inspired by this creature's violent reputation—which is well deserved. In Greek mythology, the centaur Eurytion tried to abduct Laodameia, Pirithous's bride, during their wedding feast—thankfully, this troublemaking centaur was stopped by Theseus.

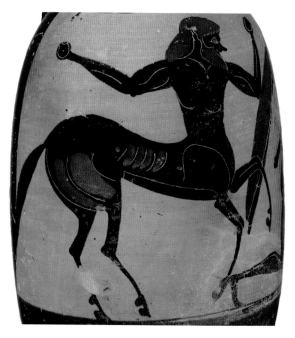

CENTAUR · *Greek*
(Lekythos, detail, attributed to the Painter of London
B 31, c. 575–50 BCE.)

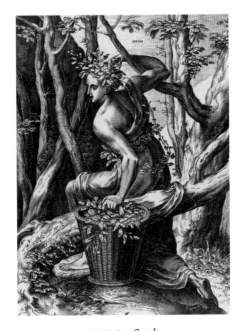

DRYAD · *Greek*
This spirit makes a home in an oak tree, and becomes
one with the tree from then on. (Engraving, detail,
by Cornelis Cort, after Frans Floris the Elder, 1564.)

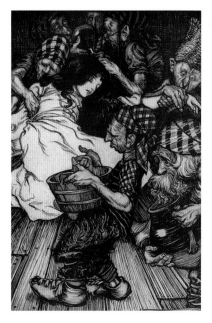

DWARF · *German and Scandinavian*
A mountain-dwelling fairy in the form of an older man,
who sometimes is a miner, and famously befriended the fair-
est of them all. (Illustration by Arthur Rackham, 1909.)

Sneaky

This diminutive, mischief-making spirit is accused of all sorts of awful deeds: it causes disease in humans and livestock, switches human children for changelings, and sits on people as they sleep, causing bad dreams. Over time, elves came to be seen as indistinct from fairies, but they are treated as separate entities in books such as J. R. R. Tolkien's *Lord of the Rings* and J. K. Rowling's Harry Potter series.

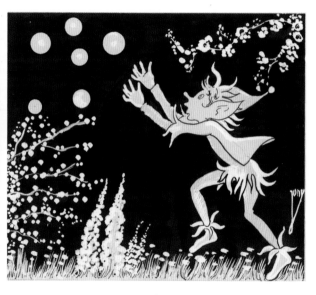

ELF · *German*
(Drawing by Jony, c. 1875–1925.)

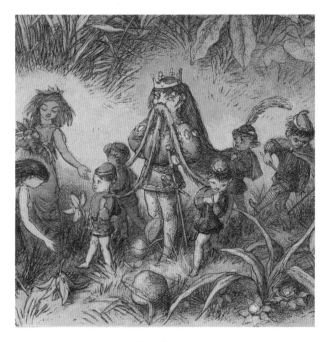

ELF · *German*
This elf king requires four pages to support his magnificent
beard. (Illustration, detail, by Richard Doyle, 1875.)

164

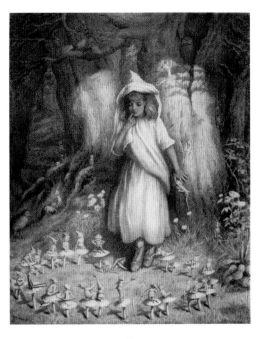

ELF · *German*
A circle of mushrooms, known as an elf ring, forms when elves dance. (Illustration by Kate Greenway, 1905.)

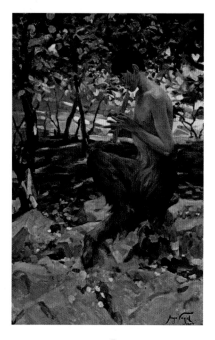

FAUN · *Roman*
A goat-man hybrid is less hairy and mean, but more musical,
than a satyr. (Painting by Hugo Vogel, 1907.)

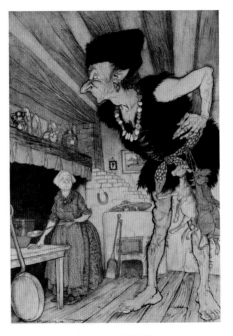

GIANT · *Global*
A large, humanlike being, known more for its strength
than wit. (Illustration by Arthur Rackham, 1918.)

Small But Mighty

This tiny, goblin-like creature guards treasure-filled mines. A gnome usually appears as a hunchbacked, wizened old man. In the sixteenth century, the Swiss alchemist Paracelsus claimed that gnomes could move through solid earth. The gnome pictured here, though, seems to have quieter hobbies.

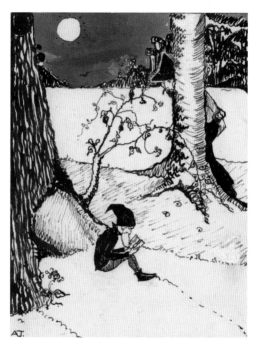

GNOME · *European*
(Drawing by A. Tinbergen, c. 1925–35.) 169

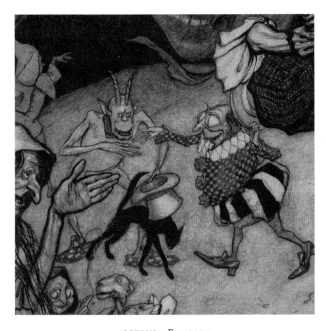

GOBLIN • *European*
Though this sprite dwells in a grotto, it is sometimes
found making mayhem in people's homes.
(*Center*; illustration, detail, by Arthur Rackham, 1911.)

GOBLIN · *European*
In one story, goblins turn Princess Singorra into a frog and
carry her through the forest. (Illustration, detail, 1912.)

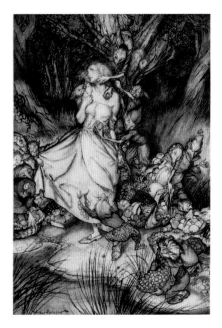

GOBLIN • *European*
In Christina Rossetti's poem *Goblin Market*, goblin
merchants try to force Lizzie to eat their fruit.
(Illustration by Arthur Rackham, 1933.)

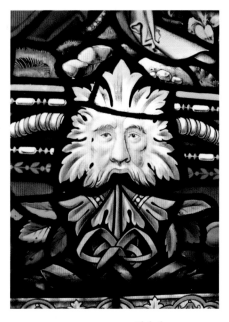

GREEN MAN • *Global*
The Green Man, who represents rebirth, is adorned
with leaves. (Welsh stained glass, detail.)

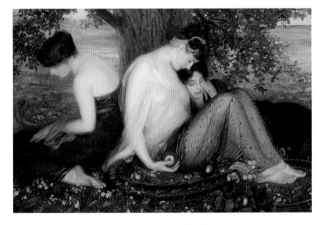

HESPERIDES • *Greek*
The Hesperides are three sisters, and wood nymphs,
who guard a tree of golden apples.
(Painting by Albert Herter, 1898.)

JACKALOPE • *North American*
A jackrabbit with antelope horns.
(Painting, detail, by Joris Hoefnagel, c. 1575–80.)

Echoes in the Woods

This forest spirit enjoys a trick, but sometimes a fun prank turns dangerous if he isn't in a good mood. A leshy can blend into his forest home to avoid being seen, like the one pictured here. His voice, though, is sometimes heard singing or laughing in the forest. He looks like a man, but usually lacks eyebrows, eyelashes, a right ear, a hat, and a belt (though he does have several of these things in the facing illustration).

LESHY • *Slavic*
(*Try to find him*; patchwork wall panel, after a sketch
by Maria Yakunchikova, 1899.)

The Forest Serpent

This giant serpent has many means of defense against its foes, such as spitting a bitter-smelling milky substance that causes blindness. In some instances, it swallows its own tail and becomes a wheel to quickly chase its prey. The facing illustration depicts a scene from a Swedish fairy tale, *The Maiden in the Castle of Rosy Clouds*, in which the hero must vanquish a lindworm to save a fair lady.

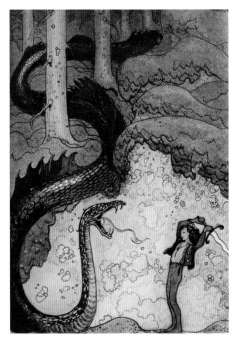

LINDWORM • *Scandinavian and German*
(Illustration by John Bauer, 1911.)

OGRE • *Global*
A gruesome creature known for eating children.
(Illustration by John D. Batten, 1916.)

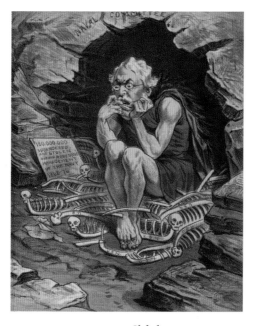

OGRE · *Global*
An ogre is depicted in a political cartoon, representing
corruption. (Chromolithograph print,
detail, by Bernhard Gillam, 1882.)

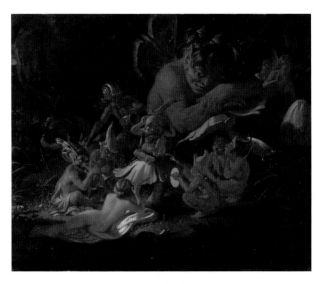

PUCK · *English*
This shapeshifting fairy (or demon) loves to make trouble:
misleading travelers, tripping people, and spoiling milk.
(*Top right*; painting by Joseph Noel Paton, c. 1850.)

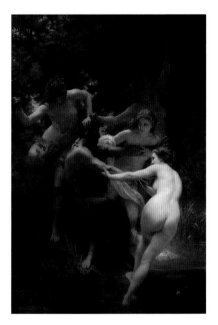

SATYR · *Greek*
A mischievous, half-man and half-goat nature
spirit—who supposedly can't swim.
(Painting by William-Adolphe Bouguereau, 1873.)

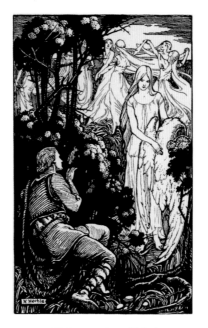

SWAN MAIDEN • *Global*

A woman who dons a swan-skin garment to transform into the bird; a man might steal the robe so the maiden remains human and marries him. (Illustration by Hilda Hechle, 1915.)

184

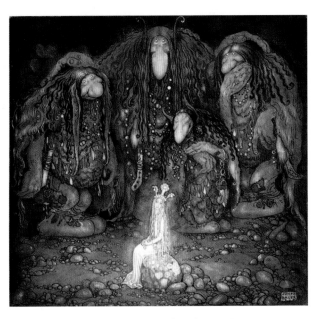

TROLL · *Scandinavian*
A grumpy creature who turns into stone if touched by
sunlight. (Illustration by John Bauer, 1915.)

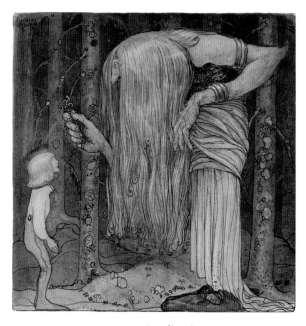

TROLL • *Scandinavian*
The benevolent Mother Troll gives a boy an herb
that allows him to safely pass through the forest.
(Illustration by John Bauer, 1915.)

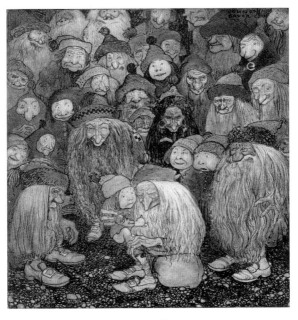

TROLL • *Scandinavian*
Trolls sometimes give directions—like here, to the
gnome boy. (Illustration by John Bauer, 1909.)

Trapped in a Web

A hairy, beastly spider (whose name means "earth spider"), the tsuchigumo is a clever spinner of webs, and few can evade its traps. In many artworks and legends, the troublemaker is depicted as a giant spider. In the story illustrated in the facing print, this creature tries to lure Minamoto no Yorimitsu into its web, but is ultimately defeated by him.

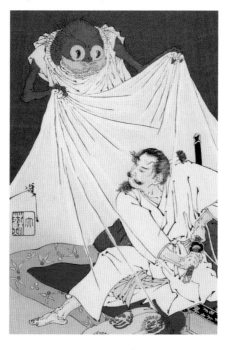

TSUCHIGUMO • *Japanese*
(Woodblock print, detail, by Tsukioka Yoshitoshi, c. 1880.) 189

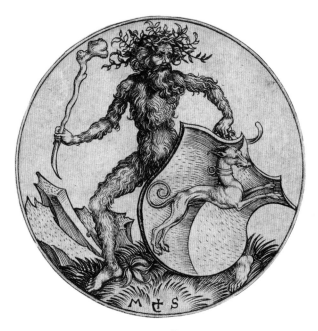

WILD MAN · *European*
This unruly man, a popular figure in medieval art,
is usually covered in hair.
(Engraving by Martin Schongauer, 1470–91.)

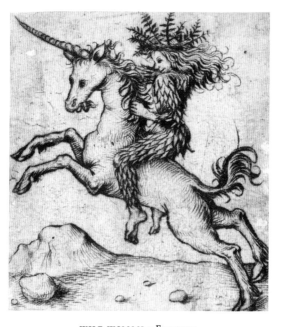

WILD WOMAN · *European*
Like her male counterpart, the hairy wild
woman is untamed, and even dangerous.
(Print by Master of the Amsterdam Cabinet, 1473–77.)

Irresistible Incandescence

This ghostly light, caused by a spirit or fairy, tricks travelers into changing their path. The light appears over watery areas, such as bogs and swamps. It can lead travelers to dangerous places, or merely disorient those journeying through forests. Other names for this apparition include jack-o'-lantern, friar's lantern, and hobby lantern.

WILL-O'-THE-WISP · *European*
(Painting by Arnold Böcklin, 1862.)

Chapter 4
WATER

Many imaginary creatures can be either good or evil, depending on the particular tale. Those living in the sea, though, are almost always malicious—except perhaps for the faithful aquatic steeds of the Hindu gods, like the makara. For much of human history, the ocean was an uncharted territory, and since the unknown is often labeled as evil, sea creatures may have been seen in a negative light by default.

With the expansion of trade in the fourteenth through seventeenth centuries, reports of sea-monster sightings began to circulate. Some were of creatures that may have seemed improbable to hearers but were later verified as real, such as the seahorse and sea lion, and others were of beasts that remain unsubstantiated, like the sea goat. As these names

for us. Water possesses some of the earth's greatest biodiversity, much of which awaits discovery. As knowledge of the earth's waters grows, and new species are discovered, it may be that some of the creatures depicted in the following pages—whether adorning pottery, carved in stone, or painted by the Pre-Raphaelites—are recognized by zoology.

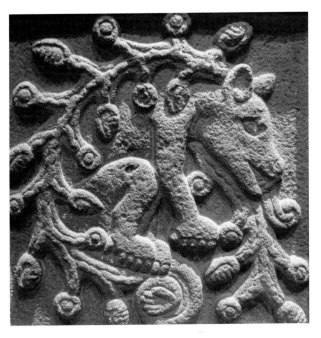

AHUIZOTL · *Aztec*
The ahuizotl, possibly inspired by a water opossum,
lures people to their deaths. (Tombstone, c. 1500.) 199

Sailors, Beware

This whalelike creature tricks unsuspecting sailors into thinking that it's an island. The sailors dismount on the island—really the creature's back—and once they light a fire to cook their food, they quickly realize that they've made a mistake. Soon they are dragged into the sea, like the unlucky fellows in this illumination from the Northumberland Bestiary.

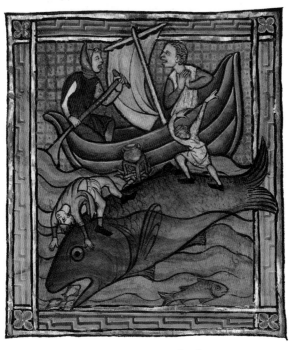

ASPIDOCHELONE · *Greek*
(Manuscript miniature, detail, c. 1270.)

BUNYIP • *Aboriginal Australian*
A fearsome beast living in Australia's swamps and lagoons.
(Illustration, 1900.)

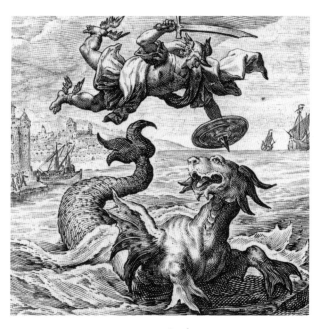

CETUS · *Greek*
This sea monster tries to devour Andromeda, but is thwarted
by Perseus. (Engraving by Crispijn van de Passe the Elder,
detail, after Maerten de Vos, 1602–7.)

FLYING FISH · *Global*
This winged fish soars above the ocean.
(Manuscript miniature, detail, c. 1250–60.)

HIPPOCAMPUS • *Greek*
A creature with the upper body of a horse and the
tail of a fish. (Bell-krater, detail, attributed to Group
of the Würzburg Scylla, late fifth-century BCE.)

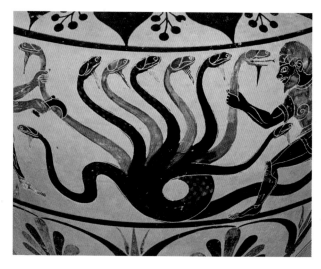

HYDRA · *Greek*

A serpent-like creature with nine heads:
if one is cut, two more grow. (Hydria, detail,
attributed to the Eagle Painter, 520–10 BCE.)

HYDRA · *Greek*
Heracles's burning torch kills the hydra.
(Print, detail, by Simon Frisius, after Antonio
Tempesta, 1610–64.)

The Bowl

This yokai appears as a turtle, except unlike that creature, it has a bowl-shaped dent on its head. This dent, known as the *sara*, is the source of its power. The sara always needs to be filled with water—if it empties, the kappa will weaken. But if someone refills the sara, the kappa will help that person for its entire life. Though this creature sometimes has malevolent intentions, it can be placated if given a cucumber.

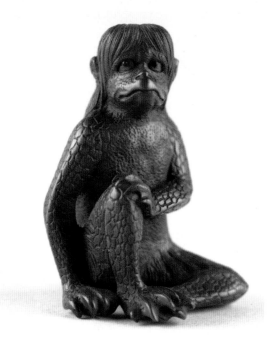

KAPPA · *Japanese*
(Netsuke, c. 1850.)

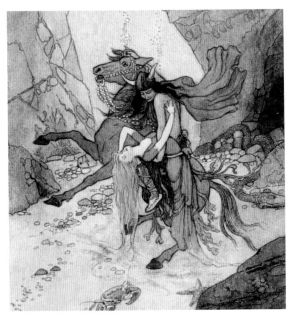

KELPIE · *Scottish*
A shapeshifting seahorse that inspired the
legend of the Loch Ness monster.
(Illustration, detail, by Warwick Goble, 1920.)

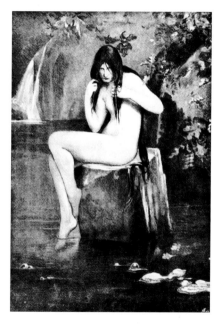

KELPIE • *Scottish*
Taking the form of a beautiful woman, a kelpie lures people
into a false sense of security. (Reproduction of a
painting by Thomas Millie Dow, 1885.)

Nightmare of the Sea

The kraken is the terror of sailors. On stormy nights, it emerges from the waters and pulls vulnerable ships into the ocean. Many sailors have claimed that it is a real creature, even larger than the giant squid, which can grow to forty feet long. Indeed, the naturalist Carl Linnaeus even included it in the first edition of his book *Systema Naturae* (it was removed from later editions).

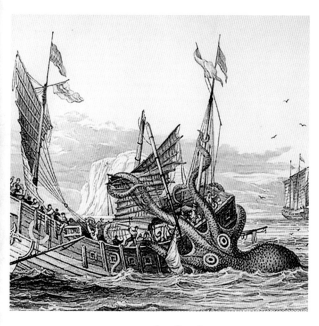

KRAKEN • *Scandinavian*
(Illustration, detail, by J. Stewart Del, 1839.)

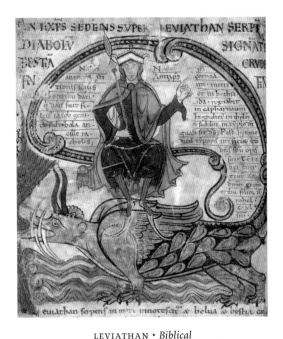

LEVIATHAN · *Biblical*
A massive sea monster, sometimes with numerous heads,
who is ruled by the Antichrist.
(Manuscript illumination, detail, 1120.)

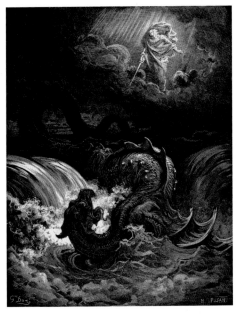

LEVIATHAN • *Biblical*
Undefeated by mortals, the leviathan is ultimately
killed by God. (Engraving by Héliodore Pisan,
after Gustave Doré, 1865.)

MAKARA · *Hindu*
This crocodilian creature symbolizes the chaos that occurs
before order is restored. (Sculpture, tenth century.)

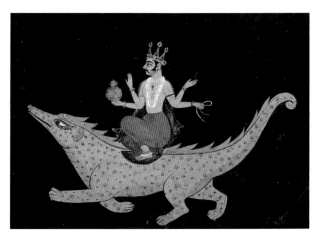

MAKARA • *Hindu*
The makara transports the ocean god Varuna.
(Painting, detail, 1675–1700.)

217

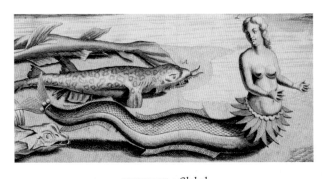

MERMAID · *Global*
This being has a human head and torso and a fish tail;
she may be friend or foe. (Line drawing, detail, by Balen,
engraved by Ottomar Elliger the Younger, 1726.)

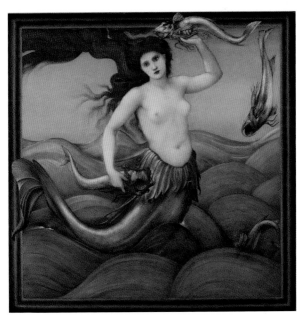

MERMAID · *Global*
Mermaids are morally ambivalent: this one is
either rescuing the fish or planning to eat them.
(Painting by Edward Burne-Jones, 1881.)

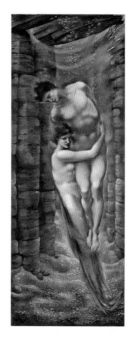

MERMAID · *Global*
This being, perhaps motivated by passion, drowns a man.
(Painting by Edward Burne-Jones, 1887.)

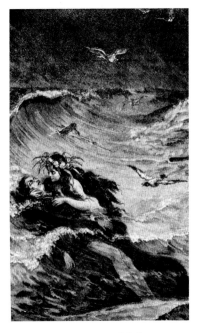

MERMAID · *Global*
A prince is rescued by the Little Sea Maid.
(Illustration, 1914.)

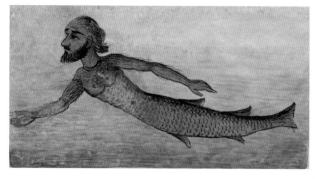

MERMAN · *Global*
Like a mermaid, a merman can be threatening to humans;
here he's depicted in the Ottoman manuscript *Wonders of
the New World*. (Illustration, nineteenth century.)

MISHIPESHU · *Northeastern Woodlands and Great Lakes*
Having bird, snake, cougar, and deer features, this beast
calms the waters where it dwells. (Pictograph, detail,
c. seventeenth–eighteenth centuries.)

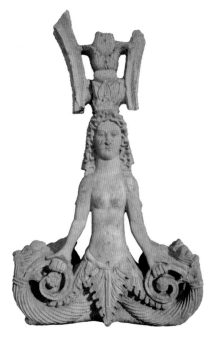

MIXOPARTHENOS · *Greek*
This creature has a double fish tail and hails from the
Black Sea. (Sculpture, first–second centuries CE.)

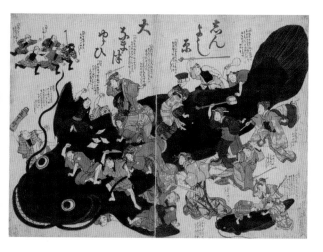

NAMAZU · *Japanese*
This catfish causes earthquakes when it isn't supervised.
(Woodblock print, 1855.)

The Repentant Ningyo

In the facing illustration of a seventh-century legend, a ningyo appears to Prince Shotoku on the shores of Lake Biwa. She explains that she returned in this hybrid form because of misdeeds from her past life, in which she killed living things without any remorse. The prince eventually absolves her by building Kannosho-ji Temple.

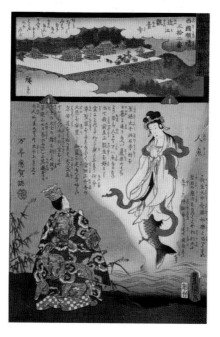

NINGYO · *Japanese*
(Illustration by Utagawa Hiroshige II, *top*,
and Utagawa Kunisada, *bottom*, 1858–59.)

227

NIX · *German and Scandinavian*
A water-dwelling shapeshifter with malevolent intentions.
(Painting by Theodor Kittelsen, 1904.)

ねこ女

NURE-ONNA · *Japanese*
This reptilian yokai has a woman's head and a snake's body,
and an appetite for humans. (Scroll painting, detail, c. 1600.) 229

A Dangerous Dance

The rusalka is a lake-dwelling being, having the soul of a drowned virgin or an unbaptized child. Her personality wavers from kindness to malevolence toward humans, according to different legends. For one week at the beginning of summer, rusalki are believed to ascend from the water, climb into willow trees, and dance in the moonlight. But beware of joining them—those who do so will dance until they die.

RUSALKA • *Slavic*
(Painting by Witold Pruszkowski, 1877.)

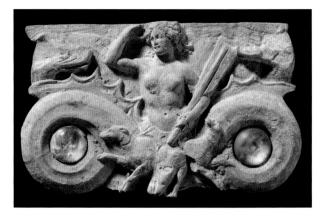

SCYLLA · *Greek*
This sea monster, who triumphantly holds a ship's rudder,
is feared by Odysseus and sailors everywhere.
(Plaque, fourth century BCE.)

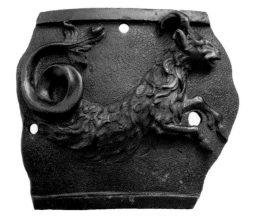

SEA GOAT • *Greek*
This water-dwelling goat is represented in the
constellation Capricornus. (Frieze, detail, 1582.)

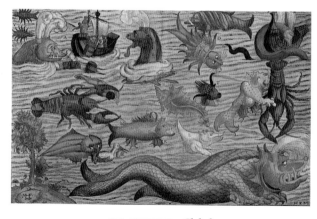

SEA MONSTER · *Global*
This beast possesses fantastic abilities and resides outside
of scientific knowledge—for now.

(Woodcut, detail, by Hans Rudolf Manuel, c. 1544.)

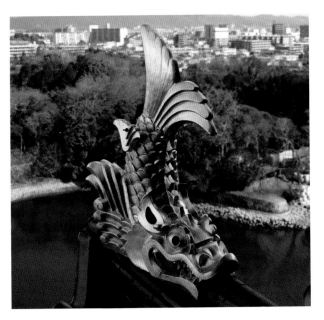

SHACHIHOKO • *Japanese*
A carp with a tiger's head, this rain-bringing creature is
found on castle roofs. (Sculpture, 1966.)

Builder of Wellington Harbour

The taniwha belongs to the mythology of New Zealand's Maori people. It is fortunate if a taniwha—like the pictured guardian Ureia—is your protector, since this serpent-like being is impressively strong, forming ocean harbors and tunnels with its body. When it isn't busy with construction, this guardian resides in rivers, caves, or the sea.

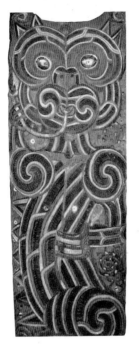

TANIWHA · *Maori*
(Carving, detail, 1878.)

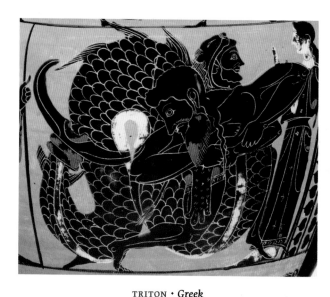

TRITON · *Greek*
A merman who fights Heracles and blows a seashell to control the waves. (Hydria, detail, attributed to an artist related to the Antimenes Painter, c. 530–20 BCE.)

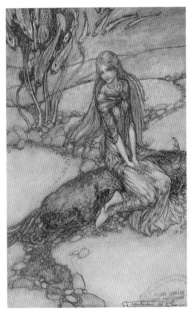

UNDINE · *European*
This water spirit sings as beautifully as she
appears, and gains a soul if she marries.
(Illustration by Arthur Rackham, 1912.)

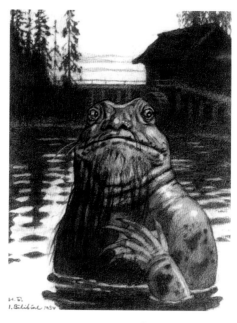

VODYANOY • *Slavic*
Favorite hobby: luring humans to watery deaths.
(Illustration by Ivan Bilibin, 1934.)

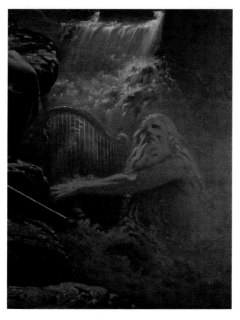

WATER SPRITE • *Global*
A water dweller, manifesting in various forms, who
is often mischievous. (Painting, detail, by Johan
Zakarias Blackstadius, 1860.)

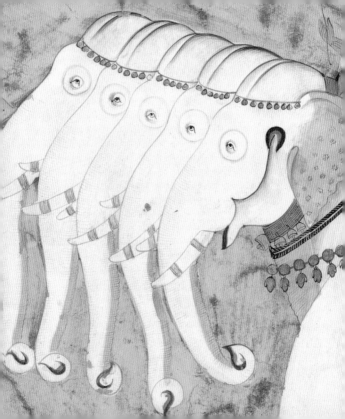

Chapter 5
DIVINE REALMS

The mythical creatures in this chapter inhabit places beyond the boundaries of our world. They dwell in the divine realms, the mysterious regions above, below, and around the earth whose existence is yet to be verified by human explorers. The divine realms are ruled by the gods and goddesses, who have the freedom to cross over into our terrestrial realm at will. Conversely, mere mortals are not permitted to enter the divine realms unless by death or the will of the deities.

Many gods and goddesses worldwide are represented with animal features—perhaps because these remote and powerful divinities seem more accessible when clothed in the appearance of familiar creatures. Several of the ancient Egyptian gods were depicted as

humans with animal heads, such as the jackal-headed Anubis or the cat-headed Bastet. Divinities with animal, or animal-human, forms are also prevalent in Hinduism, as exemplified by the monkey Hanuman from chapter 2.

Besides the gods themselves, the divine realms have various other inhabitants, many of whom also take on animal forms. Some are servants of the gods, such as the eagle Garuda, who transports Vishnu, or Cerberus and the Hellhound, who guard the underworld. Other creatures are troublemakers, and may even oppose the gods. The wolf Fenrir is chained in Asgard, home of the Norse gods, since a prophecy foretells that he will devour Odin and swallow the sun during Ragnarok, Norse mythology's version of the world's end. Another Norse animal, Ratatoskr, is a red squirrel who spreads gossips on Yggdrasill, the world tree.

In the terrestrial realm, animal features typically give mythical creatures a monstrous quality—but in

the divine realm, animal features can make them seem glorious. The angel in Abrahamic religions, who appears as a winged, androgynous human, is an awe-inspiring but welcome presence, unlike the terrifying harpies or sirens from Greek mythology.

Wherever they dwell, mythical creatures have become interwoven with human existence, providing a way for us to have a deeper understanding of our world. Though they may not exist physically, the role they play in our lives is very real. As creative manifestations of the human mind and experience, they represent our hopes and fears, embody our beliefs, and inspire our imaginations.

The Rarest Elephant

Airavata was born from a shell, along with seven other male and eight female elephants. But he was different from his siblings—his skin was a pure, glistening white. Set apart in this way, he became king of the elephants. This strong creature carries Indra, the Hindu king of the gods, upon his back. Airavata helped Indra defeat the serpent Vritra, who was holding the earthly waters in captivity.

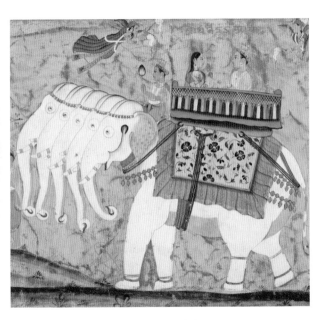

AIRAVATA · *Hindu*
(Painting, detail, c. 1670–80.)

AMMIT · *Egyptian*
This goddess is part lion, part hippopotamus,
and part crocodile, and a devourer of the dead.
(Scroll painting, detail, c. 1400 BCE.)

248

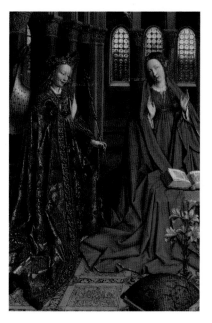

ANGEL · *Christian, Jewish, Muslim*
A winged being who often intercedes
in human affairs. (Painting, detail,
by Jan van Eyck, c. 1434–36.)

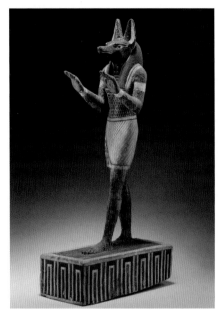

ANUBIS • *Egyptian*
This god of death has a jackal's head, and his
scales weigh the souls of the departed.

250 (Statue, c. 332–30 BCE.)

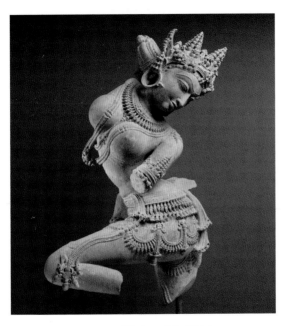

APSARA · *Hindu and Buddhist*
In many narratives, an aspara marries one of Indra's court
musicians, and dances to her husband's music.
(Sculpture, c. 1050.)

The Fiercest Feline

Bastet is the daughter of Ra, the sun god. This goddess takes the form of a cat. She is the guardian of women, mothers, and, of course, cats. If she needs to defend her kittens, she transforms into Sekhmet, a powerful and fearsome warrior with a lion's head.

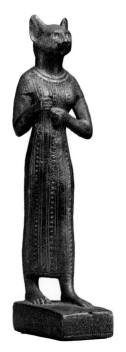

BASTET • *Egyptian*
(Statue, 664–30 BCE.)

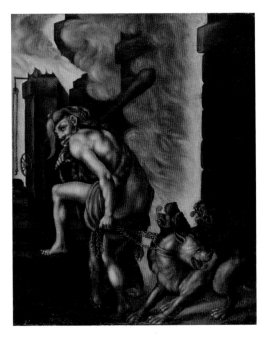

CERBERUS • *Greek*
A three-headed dog who guards the underworld.
(Painting by Philipp Uffenbach, c. 1586–1636.)

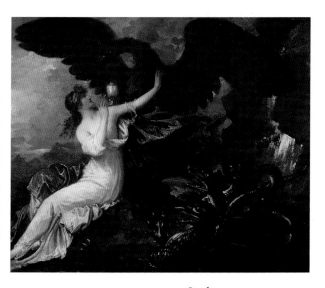

EAGLE OF ZEUS • *Greek*
Zeus either personifies or is accompanied by a mighty eagle.
(Painting, detail, by Benjamin West, c. 1802.)

A Mischievous Messenger

The god Eshu, who is associated with the Yoruba people living in Nigeria and other parts of West Africa, is an untrustworthy spirit. He is responsible for delivering messages between the gods and humankind, but he doesn't limit himself to this activity. At one point, he convinced the sun and moon to switch places, with disastrous consequences. Eventually, order was restored—until Eshu played his next trick.

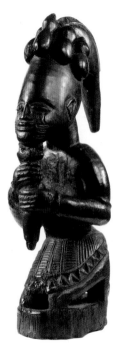

ESHU • *Nigerian*
(Statue, late nineteenth or early twentieth century.)

257

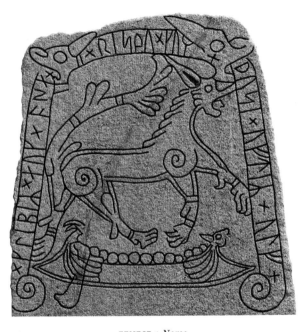

FENRIR · *Norse*
This wolf takes after his father, the god Loki, in strength,
and his mother, the giantess Angrboda, in stature.
(Runestone, c. 1000.)

258

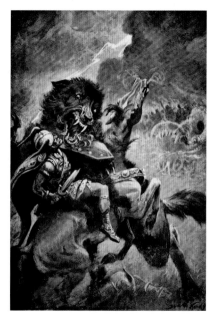

FENRIR • *Norse*
A prophecy foretells that, during Ragnarok, Fenrir will
devour the god Odin and swallow the sun.
(Illustration by Dorothy Hardy, 1909.)

259

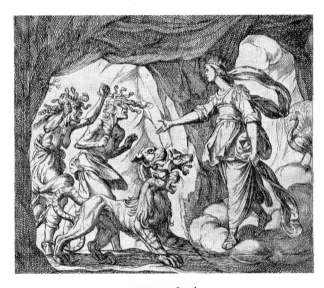

FURIES · *Greek*
These goddesses, with serpents for hair, pursue mortals
guilty of shedding blood. (Engraving, detail,
by Antonio Tempesta, 1606.)

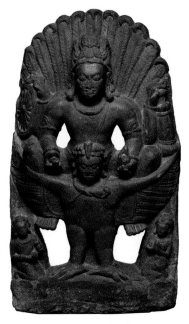

GARUDA · *Hindu*
An eagle whose wings stop the earth from spinning.
(*Bottom*; sculpture, c. 300 CE.)

Harbinger of Death

The Grim Reaper is often a skeleton draped in a flimsy shroud, carrying a scythe, and appears whenever someone is nearing death. It may have first originated in the fourteenth century, when Europe suffered from the Black Death. During this plague, nearly one-third of Europe's population lost their lives. The figure of Death in any form, whether with scythe or arrow, as seen here, is seldom a welcome sight.

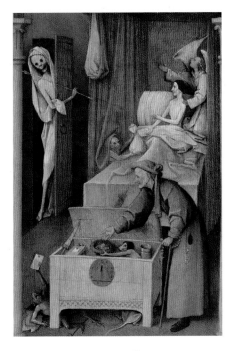

GRIM REAPER • *European*
(Painting, detail, by Hieronymus Bosch, c. 1485–90.)

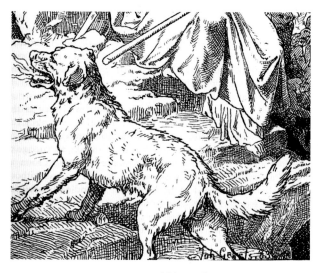

HELLHOUND · *British, Greek, Norse*
With its piercing red eyes and flaming tongue, this watcher
of the underworld is fearsome to behold.
(Illustration, detail, by Johannes Gehrts, 1897.)

HUMBABA · *Mesopotamian*
A giant guardian of the Cedar Forest, home of the gods, who
is defeated by Gilgamesh and Enkidu.
(Mask, 2004–1595 BCE.)

A Watchful Insect

This warrior goddess cares for women, particularly those in childbirth, and their infants. She rules over the realm Tamoanchan, where the spirits of women and babies find rest. As a shape-shifter, she assumes the form of a butterfly or a moth, or a woman with butterfly wings. This sculpture depicts the goddess in her insect form.

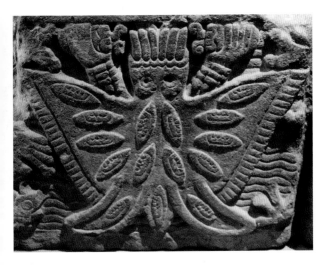

ITZPAPALOTL · *Aztec*
(Altar, detail, c. 1250–1521.)

JORMUNGANDR • *Norse*
This serpent, whose body is entwined around
the world, waits to fight Thor in Ragnarok.
(Illustration by Louis Moe, 1898.)

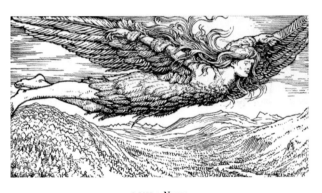

LOKI • *Norse*
A shapeshifting trickster god, who once transformed
into a falcon. (Illustration by W. G. Collingwood, 1908.)

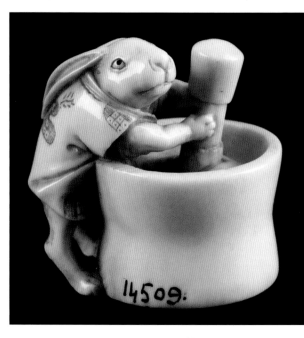

MOON RABBIT · *Chinese*

This creature, who is the shadow seen on the moon, grinds the elixir of life. (Netsuke, c. 1701–1900.)

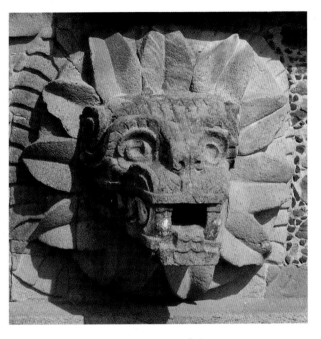

QUETZALCOATL • *Aztec*
A god of wind and light, this feathered serpent is responsible
for creating humans. (Sculpture, detail, c. 150–200 CE.) 271

A Devious Squirrel

This red squirrel lives on a large ash tree called Yggdrasill. In Norse mythology, this tree holds the world together. Ratatoskr is not a squirrel one can easily trust—he has a bad habit of spreading rumors. This wily squirrel carries lies and insults between the eagle, Vedrfolnir, at the top of the tree and the dragon, Nidhogg, residing at the bottom, which doesn't help to bring order to the world.

RATATOSKR · *Norse*
(*Center;* manuscript illustration,
detail, c. seventeenth century.)

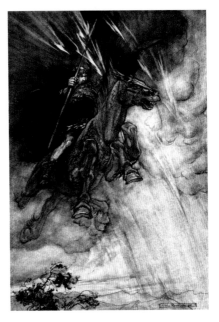

SLEIPNIR · *Norse*
Odin's eight-legged steed who rides upon sky,
land, and even the ice-covered sea.
(Illustration by Arthur Rackham, 1910.)

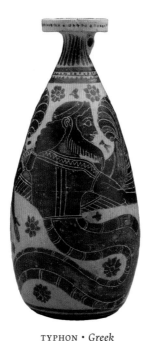

TYPHON · *Greek*

This serpentine giant, sometimes a resident of the under-
world, makes volcanoes erupt. (Alabastron, detail, by artist
close to the Erlenmeyer Painter, 610–600 BCE.)

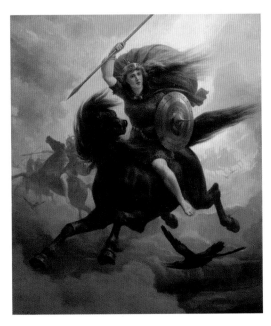

VALKYRIES • *Norse*
Warrior maidens who scour battlefields for the fallen,
whom they transport to Valhalla.
(Painting by Peter-Nicolai Arbo, 1869.)

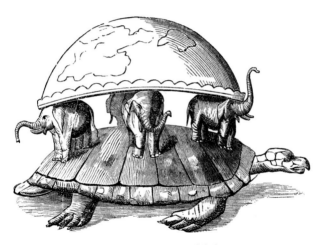

WORLD TURTLE · *Global*
A turtle containing, or supporting, the entire world.
(Illustration, 1877.)

Further Reading

BORGES, JORGE LUIS. *The Book of Imaginary Beings*. New York: Penguin Classics, 2006.

BRINKS, MELISSA. *The Compendium of Magical Beasts: An Anatomical Study of Cryptozoology's Most Elusive Beings*. Philadelphia: Running Press, 2018.

COTTERELL, ARTHUR, and RACHEL STORM. *The Ultimate Encyclopedia of Mythology: An A–Z Guide to the Myths and Legends of the Ancient World*. London: Hermes House, 2010.

DELACAMPAGNE, ARIANE, and CHRISTIAN DELACAMPAGNE. *Here Be Dragons: A Fantastic Bestiary*. Princeton, NJ: Princeton University Press, 2003.

FOSTER, MICHAEL DYLAN. *The Book of Yokai: Mysterious Creatures of Japanese Folklore*. Oakland, CA: University of California Press, 2015.

HECK, CHRISTIAN, and RÉMY CORDONNIER. *The Grand Medieval Bestiary (Dragonet Edition): Animals in Illuminated Manuscripts*. New York: Abbeville Press, 2018.

SAX, BORIA. *Imaginary Animals: The Monstrous, the Wondrous and the Human*. London: Reaktion Books, 2022.

Index of Names and Places

Photo Credits

Brooklyn Museum: pp. 58, 257 (CC-BY-3.0). *The Clark Art Institute, Williamstown, MA:* p. 183. *Cleveland Museum of Art:* pp. 61, 80, 109, 139, 151, 261. *Flickr:* pp. 39 (Douglas Brown), 50 (NCAA Official/CC BY-NC-SA 2.0), 93 (Andy/CC BY-NC-ND 2.0), 117 (Nasjonalbiblioteket, Oslo), 171 (Sue Clark/CC-BY-2.0), 184 (New York Public Library), 223 (Adam Kahtava/CC-BY-2.0), 267 (Gary Todd). *J. Paul Getty Museum, Los Angeles:* pp. 18, 22, 46, 81, 106, 123, 201, 204, 206. HARVARD ART MUSEUMS, CAMBRIDGE, MA (PHOTOS © PRESIDENT AND FELLOWS OF HARVARD COLLEGE): *Busch-Reisinger Museum:* p. 254; *Fogg Museum:* pp. 78, 220. *Arthur M. Sackler Museum:* p. 222. INTERNET ARCHIVE: *Cornell University Library, Ithaca, NY:* p. 211; *New York Public Library:* pp. 2, 128, 167, 180, 274; *Newberry Lbrary, Chicago:* p. 264; *Robarts/University of Toronto:* pp. 131, 221, 259, 269; *University of California Libraries:* pp. 75, 101, 218. *Koninklijke Bibliotheek, The Hague, Netherlands:* p. 76. *Library of Congress, Washington, DC:* pp. 31, 137, 181. *Los Angeles County Museum of Art:* pp. 6, 21, 35, 37, 73, 216, 217, 242, 247, 260. *Metropolitan Museum of Art, New York:* pp. 24, 25, 28, 36, 43, 47, 54, 59, 60, 71, 72, 91, 98, 103, 116, 129, 133, 134, 140, 141, 149, 152, 159, 190, 205, 209, 232, 233, 238, 250, 251, 253. *Minneapolis Institute of Art:* p. 219. *Muzeum Narodowe, Krakow, Poland:* p. 231. *Nasjonalmuseet, Oslo:* pp. 228 (Børre Høstland/Lathion, Jacques/CC-BY-SA 4.0), 276 (Børre Høstland/CC-BY-SA 4.0). *National Gallery of Art, Washington, DC:* pp. 55, 147, 175, 249, 263. *National Library of Australia (TROVE):* pp. 14, 97. *National Library of Medicine, Bethesda, MD:* p. 19. *Nationalmuseum, Stockholm:* p. 241. *New York Public Library:* pp. 69, 79, 90, 142, 164, 170, 213, 239. *Princeton University Art Museum,*

SELECTED TINY FOLIOS FROM ABBEVILLE PRESS